INDIGO

First published in the United Kingdom in 2018 by
Pavilion
43 Great Ormond Street
London
WC1N 3HZ

Distributed in the United States and Canada by
Sterling Publishing Co., Inc. 1166 Avenue of the Americas, New York, NY 10036

First published by Natur & Kultur, Sweden
Original title: En Handbok Om Indigo, Färgning & Projekt

ISBN: 978-1-911595-62-5

A CIP catalogue record for this book is available from the British Library

10 9 8 7 6 5 4 3 2 1

Reproduction by Mission Productions Ltd, Hong Kong
Printed and bound by Leo Paper Products Ltd, China

This book can be ordered direct from the publisher at www.pavilionbooks.com

Publisher's Note: This book is sold without warranties or guarantees of any kind, expressed or implied, and the publisher and the authors disclaim any liability for injuries, losses or damages caused in any way by the content of this book or the reader's use of the techniques and ingredients needed to complete the projects presented herein. The publisher and the authors urge readers to thoroughly review each project and to understand the use of all techniques and ingredients before beginning any project. The safety notices on pages 56–57 are not exhaustive and medical attention should always be sought in the event of an accident.

cultivate | dye | create

INDIGO

KERSTIN NEUMÜLLER

DOUGLAS LUHANKO

PAVILION

Foreword 7

WHAT IS INDIGO? 11

History .. 12

Synthetic indigo ... 13

The white core ... 14

From plant to pigment ... 16

GROWING INDIGO PLANTS 21

Indigofera .. 22

Japanese indigo ... 24

Woad ... 26

Hapa-zome .. 30

DYEING WITH INDIGO 35

The different indigo vats ... 36

Dyeing with dry indigo pigment ... 39

Preparing the material ... 40

The dyeing stage ... 43

Wringing out the material in a different vessel 43

Oxidizing the indigo ... 44

Repeated dips .. 44

Tones .. 46

Rinsing and washing ... 46

Discarding a dye vat ... 47

Troubleshooting .. 49

RECIPES 55

In the event of an accident ... 56

Gösta Sandberg's hydrosulfite vat ... 59

Banana vat .. 62

Fructose vat .. 66

Warm dyeing with Japanese indigo .. 68

Fresh Japanese indigo with iced water 70

Fresh woad vat..74

Fermented vats...77

 Fermented vat with wheat bran................................78

Indigo in combination with other pigments....................80

 Dyeing cotton and wool with plant dyes...................82

 Mordanting with alum..82

 Yellow colours with birch leaves.............................83

 Red colours with common madder...........................84

 Recipe for iron and tannin.......................................85

PROJECTS 89

Shibori..91

 Honeycomb *shibori*..93

 Arashi shibori..97

 Itajime shibori...99

 Gradual colour transitions....................................103

Sashiko..109

 Moyo-sashi: asa-no-ha, the hemp leaf pattern....110

 Hitome-sashi: kaki-no-hana, the persimmon flower pattern...112

Patching and mending...115

 Patching with running stitch..................................117

 Darning..118

 Patching a hole with folded edges.........................120

 Patchwork quilt..124

Ikat..129

Blue prints...130

Materials...132

 Plant fibres..132

 Animal fibres..134

Glossary..136

Acknowledgements...140

FOREWORD

On the cold, grey November day that we first met, I was looking for someone to dye indigo with and, by chance, stepped into Douglas's shop on the very day he had ordered a starter kit for natural indigo dyeing. Since then, we've explored indigo's possibilities and limitations together. Douglas has dedicated his working life to denim and creates handmade jeans, and I'm a mens' tailor with a strong interest in handicrafts. Together, we run the shop Second Sunrise in Södermalm, Stockholm.

Indigo has been used to colour textiles blue for over 6,000 years and has played a significant role in different cultures, not least in our own time. Perhaps it is for this reason that there are more myths and legends attributed to the indigo pigment than any other. Among other folk tales, it has been mistaken for a mineral, it has been called 'the devil's dye', and a current common myth is that you have to use urine to fix the blue dye. Another subject to ponder is just why indigo became synonymous with workers' clothes.

After reading countless guides and putting their instructions into practice in order to grow and dye with indigo plants ourselves, we are delighted to have compiled everything we've learned into this book and we hope it will be of help to those wanting to dye with indigo. We want to show that indigo dyeing doesn't have to be any more difficult than baking scones on a Sunday morning. Happy reading!

Douglas Luhanko and Kerstin Neumüller

Indigo plants grow naturally in the blue areas.

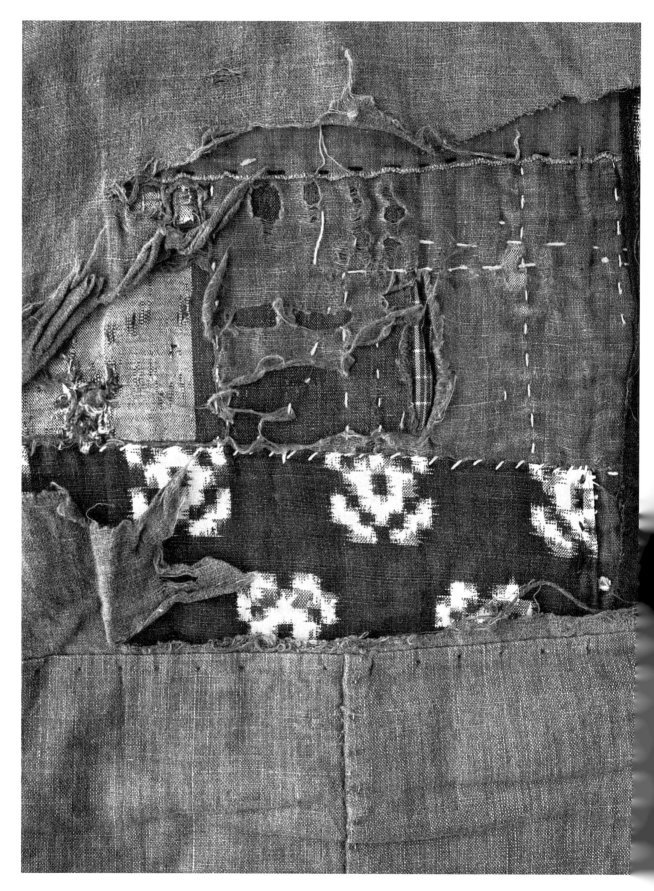

Detail from a Japanese patchwork quilt made from several layers of indigo-dyed fabrics.

WHAT IS INDIGO?

Indigo is a rich blue colour that can be extracted from plants. There are an incredible 800 or so plant species across the globe that all contain a substance that, together with oxygen, creates indigo pigment. Only a handful of these plants, however, contain high enough levels of the substance to make growing them for dye production worthwhile. Indigo can also be produced synthetically.

Dyeing with indigo is a skill that seems to have emerged simultaneously in several different places around the world in prehistoric times, despite the complex preparation work that's required before the dyeing process can start. We see this as an example of how humanity's curiosity can lead to similar solutions being discovered in different places, completely independent of one another, before spreading to other regions.

The word 'indigo' derives from the Greek word *indikon*, which later became the Latin word *indicum*, and literally means 'from India'. The majority of indigo used today is synthetically produced, but you can get hold of naturally produced pigment and it's also perfectly possible to grow plants containing indigo at home.

History

Colouring with indigo is an art that goes far back in time and the pigment is regarded as one of the oldest plant dyes for textiles. Ancient indigo-dyed textiles have been found in different parts of the world and the oldest find is dated to around 4,200 BC from Huaca, Peru.

At that time in Europe, they hadn't developed a technique for extracting pure pigment from the brassica plant, woad. Instead, indigo was preserved and transported by crushing the leaves and rolling them into balls that were then dried. Since indigo came from the East in the form of blue cakes, for a long time there was a common misconception that indigo was a mineral. It wasn't until the end of the 13th century, when Marco Polo returned from his travels to Asia, that this myth was debunked.

Woad continued to be the main source for blue colours in Europe until the 15th century, when Vasco da Gama made seaborne trade possible with India. By then, indigo dye could be imported in greater quantities instead of the limited amount that had previously reached Europe via the trade caravans of the Silk Road.

But indigo from the East didn't get a warm welcome everywhere and in some regions laws were introduced that banned the use of imported indigo, since it threatened to eliminate local woad production. The new indigo was both cheaper and more efficient to dye with, but in some areas breaking the law was punishable by death.

During the 17th century, imported indigo was named 'the devil's dye' by Ferdinand III of Hungary, and it wasn't until 1800 that the use of imported indigo became legal in the whole of Europe.

Synthetic indigo

It's almost impossible to talk about indigo's history without mentioning slavery and human suffering. During the mid-19th century, indigo was a sought-after commodity and the demand for it increased with the industrialization that steamed ahead in the Western world. During this time, many areas that offered good conditions for indigo cultivation were colonized by the most powerful countries in Europe and plantation owners quickly realized that there was a lot of money to be made. In India and South America, large indigo plantations spread across the countryside, but the local inhabitants and slaves who had to work on them paid a high price; the demand for indigo increased to such an extent that in India, indigo was favoured over other crops – including staple foods – which lead to famine and misery for much of the population.

As such problems increased, chemists attempted to invent a way to produce synthetic pigments that were both more efficient and cheaper than the ones that the plant world had to offer. In 1880, the German researcher Adolf von Baeyer successfully synthesized a pigment with the same chemical composition as natural indigo pigment and, later in 1883, formulated its structure. The result was synthetic indigo that contained a greater quantity of indigo and was also easier to dye with, since its qualities were more consistent and therefore better suited for the industry's needs than natural indigo. It wasn't long before this new synthetic indigo made the natural version redundant, just as the Eastern indigo had out-competed woad a few hundred years earlier.

The dilemma with indigo today is not only that synthetic indigo has a negative effect on the environment, but that it is impossible to grow enough of the natural variety to meet the demand of modern industry. Research into the subject is ongoing and hopefully there will be environmentally friendly alternatives for producing and using synthetic indigo in the future.

The white core

Jeans and denim have always been synonymous with indigo – from the California Gold Rush in 1848 to today. Jeans first began as workers' clothes, then became associated with rebel youth culture and today are one of the most common garments in our wardrobes.

Almost all the world's indigo is used for dyeing denim, and you could say that the increasing popularity of jeans in the middle of the 20th century saved indigo. During this time, alternative blue dyes had started cropping up that were both cheaper and more durable, but the unique way in which indigo ages and fades could not be bettered, and that has guaranteed that indigo continues to remain the blue in blue jeans.

The most likely reason for the popularity of jeans is the winning combination of the qualities of cotton and indigo. Cotton is warming, durable and can be cultivated on a large scale, while indigo gives a beautiful colour and strengthens the material since the pigment's molecules attach to the cotton fibres. These qualities are woven together in denim, a twill-woven fabric with an undyed weft and indigo-dyed warp – it saves both time and money to dye only the warp. The thread is spun before it is dyed with the result that the indigo dyes the outside of the yarn but doesn't reach the middle, creating a blue coating and a white core. The fabric is usually woven so that the weft runs under three warp threads and then over one, with the result that the durable facing is mainly indigo and the reverse almost undyed.

The indigo dye is worn off in time, which contrasts with the white core of the thread. The wear and tear on any denim garment gives an insight into what the person who was wearing the garment experienced. Their life leaves its trace in the jeans, whether that life was of someone who was searching for happiness with a pick axe in 19th-century America or of a small child today, whose antics in the park tear holes in the knees.

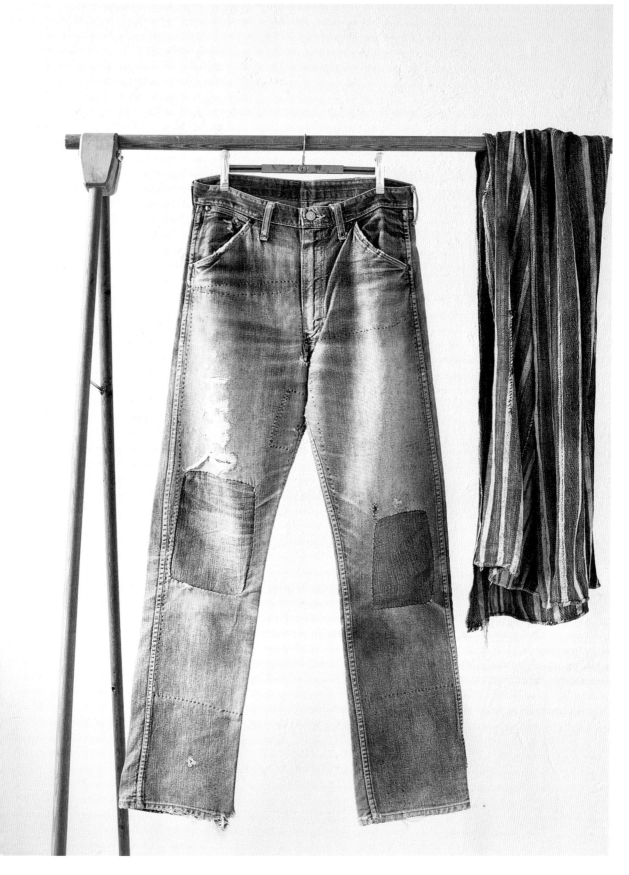

A pair of well-worn and carefully patched Wrangler jeans from the early 1960s.

From plant to pigment

When you start reading about indigo dyeing, it will not be long before you encounter the phrase 'indigo vat'. It refers to a process called 'reducing', and it's this process that makes indigo different from other plant dyes. Indigo isn't soluble in water and must first go through a reduction before you can use it for dyeing. This means that you use an alkaline, oxygen-free solution to temporarily change the pigment's chemical structure into a stage called 'indigo white', or 'leuco-indigo'. The indigo is transformed and the molecules shrink and become almost colourless. When a dyed textile is removed from the vat and reacts with oxygen, the indigo molecules revert back to their original state. They regain their blue colour and expand again, which means they stick to and in between the fibres in the material.

In order to store and ship indigo, the fresh green plants need to be processed into a stable substance that won't rot; they can come either in the form of dried leaves or indigo pigment, and it is these products that are used to start a dye bath. There are different ways to refine the fresh plant, and we divide them into dry fermentation and wet fermentation.

DRY FERMENTATION is common in Japan and West Africa. In Japan, the process is called *sukomo* and involves composting the leaves under careful scrutiny. In West Africa, the leaves are crushed and kneaded into balls that are then dried. There are two main reasons for doing this: the first is to start off a fermentation process to encourage a bacterial culture which is useful for a fermented vat; the second is that the dried leaves can be stored, which is good for trading.

WET FERMENTATION is common in India and South America. The plants are placed in large tubs that are filled with water and, quite soon, a degradation process starts, during which

the plants release a red-brown substance called 'indoxyl'. The time in which the indigo ferments can vary from a few hours to a few days depending on climate, season and temperature. Afterwards, the water is strained into a different tub and is aerated by a brisk stirring.

When the indoxyl comes in contact with oxygen, it transforms into indigotin and the water turns visibly blue. The indigotin is then left to sink to the bottom and any excess water is drained off. What's left is a blue sludge of indigo that is dried and then packed, stored and sold.

Depending on where the plant is grown, indigo powder made from *Indigofera tinctoria* can contain 10 to 50 per cent pure indigo; it can also contain up to 5 per cent indigo red and indigo brown. It is said that the red and brown gives natural indigo more beautiful tones than synthetic indigo, which only contains blue pigment and is 90 to 95 per cent pure.

Indoxyl, indican, indigotin

Indoxyl is a colourless substance that can be found in green indigo-producing plants and, together with the glucose, which is made in the plant by the process of photosynthesis, creates indican. The exception is woad, where an acid fills the role of the glucose.

When the leaves are picked off the plant, the indican starts to degrade through the action of natural enzymes in the plant, and reverts to indoxyl.

If you then add alkali and oxygen, the indoxyl is transformed into indigotin, which is what we call the indigo pigment. This is the blue powder that can be saved, stored and used for dyeing.

To reduce the indigo pigment before dyeing, an alkali and an oxygen-reducing agent are added, which transforms the molecule into indigo white, a process that is necessary for fixing the indigo onto the fabric. When in contact with oxygen, the indigo pigment reverts back to its original state and becomes blue again.

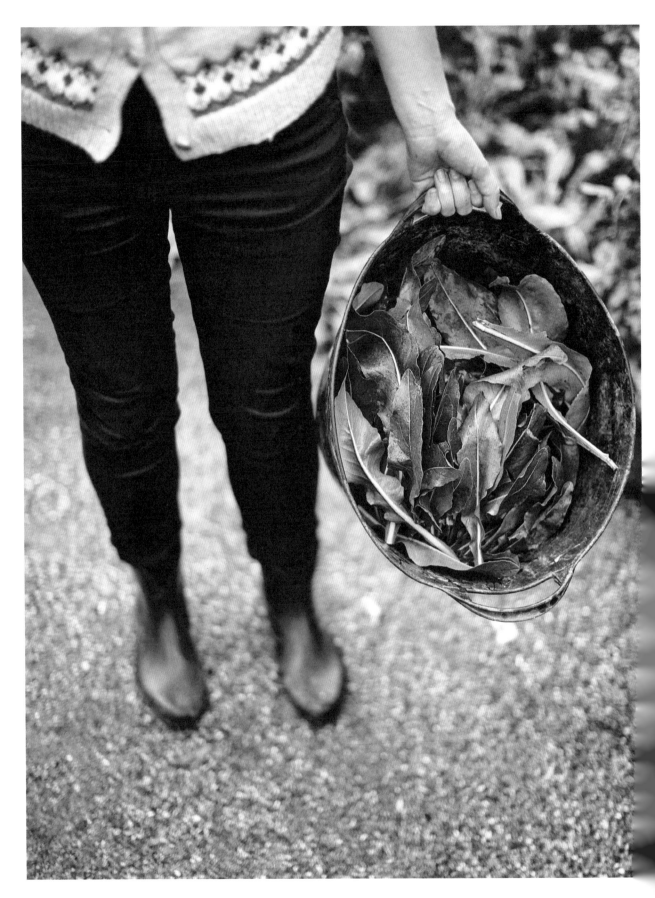

The harvested leaves of woad, *Isatis tinctoria*.

GROWING INDIGO PLANTS

It is perfectly possible to produce blue dye from your own indigo, grown inside or in the garden.

Our expert growing tips have been written by our friend Kaili Maide. She is a gardener at the Bergius Botanic Garden in Stockholm so her tips were originally written for central Sweden. Most indigo-producing plants are, however, half-hardy plants like a dahlia or a tomato. They will grow best in warm, bright locations, approximating to RHS H3, USDA 9b/10a, European hardiness zone 9, and in the more warm and moist regions of Australia.

It is possible to grow indigo as an annual in cooler or more northern areas – throughout the UK and in large parts of the US and Europe. What can be grown where is also affected by altitude, shelter, rainfall, light intensity and so on. These plants needs a long growing season and plenty of light and heat, so start the seeds off in pots in a greenhouse or on a warm windowsill, six to eight weeks before the last frost. When the weather and soil are warm and the risk of frost has passed, plant them out in a sunny spot and keep them well watered.

In colder areas, indigo-producing plants can be grown indoors or in a greenhouse, again with plenty of light to stimulate indigo production.

Indigofera
(Indigofera tinctoria, Indigofera suffruticosa, Indigofera australis)

Indigofera belongs to the family Fabaceae. They thrive in subtropical climates and have historically been used for blue dyeing in many different cultures. Common to all *Indigofera* species is that they contain indican, but only a handful of them contain a high enough concentration of it to produce indigo on a large scale.

Plants in the genus *Indigofera* are perennials but can be grown as annuals depending on your location and climate. You should be able to grow them outdoors in all parts of the UK, but if you experience colder winter temperatures you would be better to grow them in a pot indoors, in a greenhouse or in a conservatory. You can also grow them in raised beds. Of the three *Indigofera* species we've mentioned here, *I. australis* will fare best outdoors. *Indigofera* fold down their leaves at night and look like they're wilting, but will fold them out again when the sun rises. It's easy to think that they are drying out and want more water in the evening but wait until the morning and you'll see that they're well and thriving.

The seeds are sown at the end of the winter. To make sure they germinate, they should be soaked in water for 24 hours before sowing, then sown into a good seed compost. Once the plants have sprouted, they grow fairly slowly at first. After a couple of months, they will be big enough to replant in all-purpose compost in bigger pots. Indigo plants love light, so give them as much as possible right from the start. The plants can grow up to 1.5 metres/5 feet tall and may need support when they get a bit taller. During the summer months, it's important to water the plants regularly. Make sure that the plants' compost never dries out completely but avoid waterlogging. Feed them once a week using general purpose liquid fertilizer according to the instructions on the bottle.

Indigofera plants that are grown in a greenhouse run the risk of becoming infested with whiteflies and red spider mite. If you have other pot plants near the *Indigofera*, you should check them over since these pests will quickly spread between different plants. Spray affected plants with a soap spray made up of 100ml/3½fl oz liquid soap in 5 litres/8¾ pints water once a week. For severe infestations, repeat the spraying several times a week.

Indigofera will not survive in cold temperatures and frost, but can be overwintered at a temperature of above 20°C (68°F) with as much light as possible – preferably with an extra plant light during the winter months.

HARVESTING The indigo content is said to be at its peak just as the first flowers are appearing. *Indigofera* is harvested in the same way as Japanese indigo (page 24), but in cooler climates will usually only give just one yield per year.

23

Japanese indigo
(Persicaria tinctoria)

24

Commonly known as Japanese or Chinese indigo, or dyer's knotweed, this plant was previously classified as *Polygonum tinctorium*. It is believed to have been exported from the southern parts of China to Japan some time around AD 500 and has since been the main indigo plant in Japan. This species of indigo can be grown north of the equator as long as it is not exposed to frost. During the 18th century, there were attempts to grow the plant in Europe because it contains more indigo pigment than woad. It comes in different varieties with either rounded or spiky leaves and the flowers can be pink or white.

Japanese indigo is suitable for growing outdoors, in raised planters, urns, pots or larger balcony boxes. The plants are pre-cultivated indoors or in a greenhouse six to eight weeks before the risk of night frost has passed. Harden off the plants and cover with a plant-protection fleece during the early stages of growing to get the plants off to a good start.

When planting in pots or containers, it is best to use a good-quality compost. If you put the plants outdoors, the soil should be well worked and fertilized with farmyard and

pelleted chicken manure, which will provide plenty of nitrogen for green growth. Space the plants 30–40cm/12–16in apart. In good conditions, the plants will grow to about 1 metre/39in high and branch out sideways so will need a lot of space.

The plants can be propagated by leaving a few cuttings in water for a few days to grow roots. When they have a good tuft of roots, it's time to plant them out.

The plants will thrive from mulching the surrounding soil with grass clippings, which will keep weeds at bay, retain moisture in the ground, provide nutrients and give a better soil structure. Water liberally during hot and dry periods. Plants grown in containers need watering every day.

Japanese indigo is rarely troubled by pests when grown outdoors. However, in a greenhouse, greenflies and red spider mites can be a problem. Spray the infested plants with a soap spray made up of 100ml/3½fl oz liquid soap in 5 litres/8¾ pints of water once a week. For severe infestations, repeat the spraying several times a week.

HARVESTING Harvest in late summer before the plant flowers – that's when the indigo content is at its peak. Cut down the plants to 10–15cm/4–6in high, so that the plants can quickly grow new shoots. Fertilize and water afterwards and you can get several harvests in one year.

In the autumn or in cold weather, the plants can be protected with a plant-protection fleece. Japanese indigo is very sensitive to frost and will not survive the winter, so harvest the whole plant at the end of the season. The seeds can be saved and used for next year.

Woad
(Isatis tinctoria)

Archeological finds confirm that woad has been grown in Europe since the Neolithic Age, around 8,000–3,000 BC. Its common names include dyer's woad and, less commonly, glastum or the asp of Jerusalem. It self-seeds in the UK and its yellow flowers appear in spring. It particularly likes lime-rich coastal areas. Just like *Indigofera tinctoria*, woad contains indigo, but the concentration of pigment is 30 times lower.

Woad is a biennial plant. The first year, it comprises a rosette on the ground and during the second year it grows a stalk with yellow flowers. You can pick your own seeds for the next growing season, but do cut down most of the fruit-bearing stems. Woad self-seeds and can quickly spread out over large areas if it gets the chance! In some American states, woad is classified as a non-native invasive weed and has undergone an eradication programme.

Woad is suitable for growing outdoors and can be sown directly in the ground in spring when the danger of late frosts has passed. Plants can be started earlier in seed trays in a cool greenhouse; if it is too warm, the plants will become leggy and

may not thrive when planted out. Harden off pre-cultivated plants before planting them outdoors by leaving them in a shady place during the day for one week, bringing them in at night.

Woad should be planted in well-fertilized and worked soil. Make rows 25–30cm/10–12in apart and space the plants every 15–25cm/6–10in. You can then thin out the plants when they appear so they are as close together as you wish. If you are planning frequent harvests, put the plants closer together, but if you want to leave them to spread, keep them further apart.

Fertilize the soil with farmyard and pelleted chicken manure at least two weeks before sowing or planting out. If the plants are not growing strongly you might need additional fertilizer during the summer months, in which case work chicken manure into the soil in between the plants, following the recommendations on the packaging. Keep well watered in dry weather. Weed and loosen the soil around the plants occasionally.

Small woad plants can often get infested by flea beetles. A mild infestation will just lead to small holes in the leaves, but a heavy infestation can kill the plant. Sow seeds into warm, moist soil so that they grow quickly and become less vulnerable. Excluding the adult beetles by covering the plants with an insect-proof netting may also help as, anecdotally, does sprinkling wood ash around the plants.

Woad can be grown indoors in pots, but often the plants will become weaker than when growing outdoors and are prone to insect infestations, such as from greenflies.

HARVESTING Harvest in high summer. You can gather some of the leaves in the first year, but leave the middle of the rosette to grow and produce more leaves and flowers in the second year. After harvesting, give the plants some extra fertilizer and water. An established woad plant can survive several degrees below freezing in winter, but the indigo level will drop drastically the colder it gets. The following year, once the temperature rises, the indigo levels will increase and you can start dyeing again.

The pointed leaves of Japanese indigo, *Persicaria tinctoria*.

Hapa-zome

There is a very easy way of finding out whether the fresh leaves you have been growing contain indigo. *Hapa-zome* is a Japanese term that means 'leaf dyeing' and the technique involves hammering a leaf between two pieces of a natural fabric, such as cotton, in order to create an impression. Most plants can be used but species containing indigo work particularly well, since the pigment in the plant is in its colourless preliminary stage and doesn't oxidize and turn blue until it is incorporated into the fabric. Not only is it a very quick way of dyeing, it's also fully environmentally friendly.

— *fresh leaves from an indigo plant*
— *pieces of fabric made from natural fibre*
— *hammer*
— *warm water*
— *washing-up liquid*

Place the leaf in between two pieces of fabric on a firm surface and bash it with a hammer so you have an impression that looks like a green leaf. Leave in the air for 1 hour, then rinse the fabric with a little warm water and washing-up liquid. The green chlorophyll will start to break down and, if the leaf contains indigo, a blue print will appear. On some fabrics it can be difficult to rinse out the green colour. If this happens, leave the fabric out in strong sunlight and the sun will take care of it.

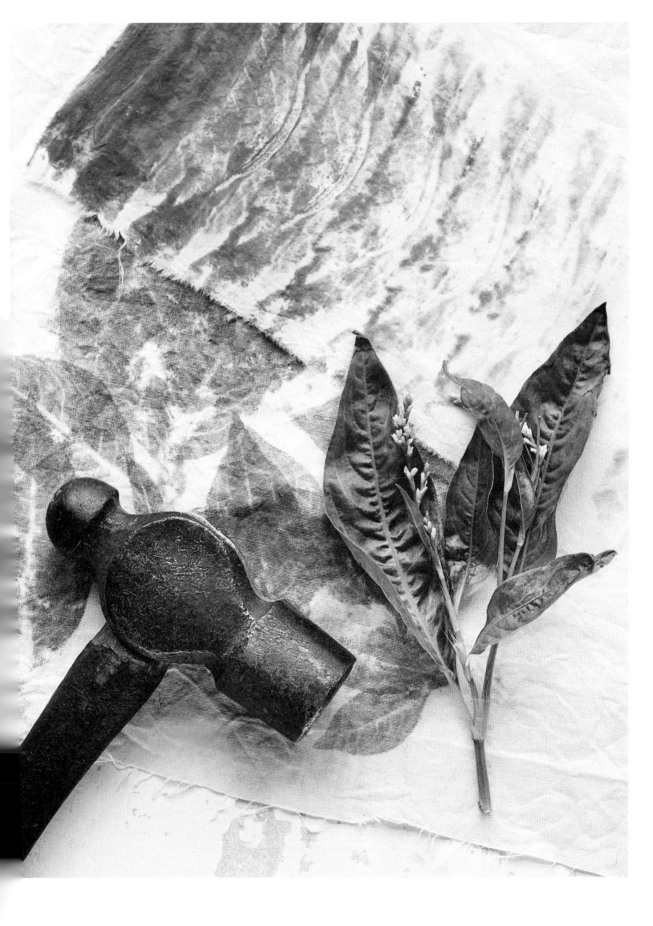

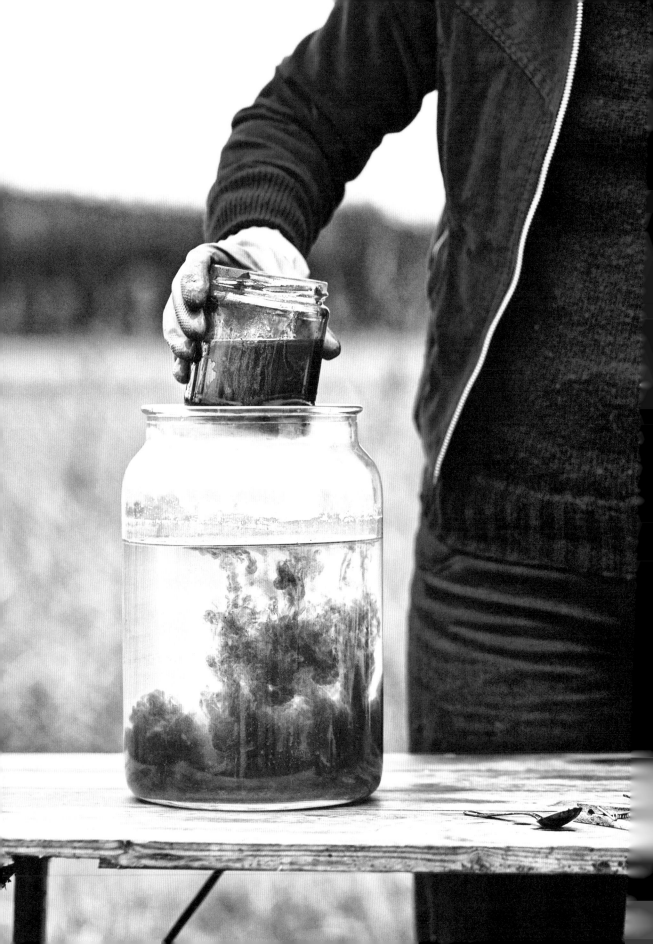

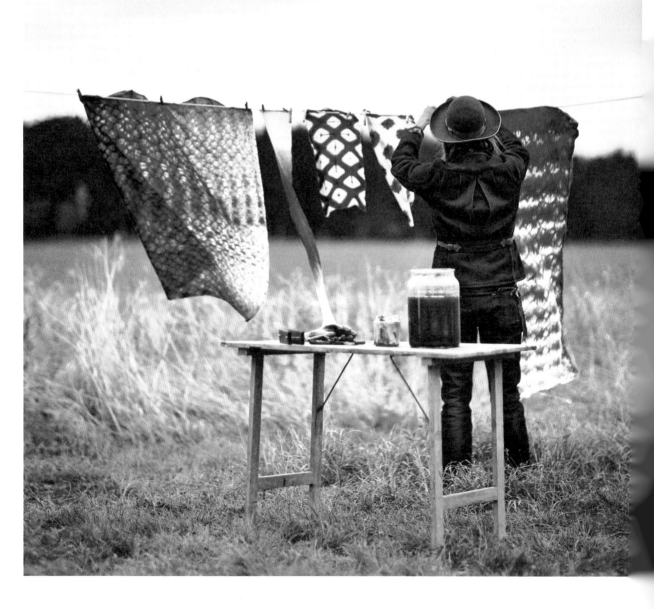

DYEING WITH INDIGO

Dyeing with indigo is a lot like baking bread. A fermented vat depends on a bacterial culture to bloom, just like how you encourage yeast to develop when proving sourdough bread. And the recipes that contain acid-reducing substances are similar to scone recipes – they're quick to whip up and give fast results.

All indigo recipes actually fulfil the same purpose: to get the indigo to a stage where it can fix onto a textile fibre. This is called 'reducing' and can be achieved in different ways. There are two prerequisites for making a successfully reduced indigo vat: a high pH value between 7 and 10, and something that reduces the amount of oxygen in the dye bath.

The different indigo vats

There are indigo vats that you can prepare at home that are similar to those used in the textile industry. They are adapted to give a fast and effective result and you can also increase the amount of dye in the bath as you see fit. On the flip side, you would have to use strong chemicals such as sodium hydroxide and sodium hydrosulfite to reduce the indigo, compounds that are harmful to both people and the environment if they are handled the wrong way.

Before the 16th century and the discovery that metal salts could be used to reduce indigo, all vats were made using natural ingredients. The two prerequisites – high pH value and an oxygen-free environment – can be achieved without using strong chemicals. For example, it is possible to use slaked lime to increase the pH value and sugar to reduce the oxygen in the water. You can use fructose for a quick-reduced vat, or granulated sugar to start a fermented vat. Regardless of your technique, a vat based on sugar is less harmful to the environment than ones containing sodium hydrosulfite.

In Cajsa Warg's book *Guide to Housekeeping for Young Women*, published in Sweden in the 18th century, there is a recipe for an indigo vat that uses just two ingredients: indigo and urine. The urine is placed somewhere warm and when it starts to ferment, the oxygen level reduces and ammonia forms, which creates an alkaline environment.

In Japan, it's common to prepare leaves from Japanese indigo by partly composting them. The result is called *sukomo* and contains a bacterial culture that is beneficial for fermentation. This means that vats made with *sukomo* are relatively quick to get started when the time for the actual dyeing comes around. In contrast, vats that are fermented with indigo in the form of a pigment will need more time to develop a suitable bacterial culture.

Today we know exactly what happens with the indigo from plant to pigment, but that knowledge is relatively recent if you consider the long history of indigo. It's interesting to think about the people who dyed with indigo in a time before thermometers, pH indicator paper and modern chemicals. They had to fully rely on their senses, especially sight, smell and taste, to decide when the vat was ready.

What is pH?

Do you remember your teacher explaining pH values in a chemistry lesson? Maybe in class you licked a litmus strip and found that the pH value of your saliva was neither acid nor alkaline. It's quite likely that you found it as difficult as we did to think of any circumstance in which this knowledge would be put to good use. Well, that day has now arrived! And we've included a note below to refresh your memory on what pH values are to help you understand the chemistry behind indigo dyeing.

The pH value is a measurement of acidity, that is to say a measurement of the concentration of hydrogen ions (H+) in a solution. Solutions with a low pH value are acidic and are therefore called acids, and those with a high pH value are called alkalis. Solutions that have a pH value of 7 at 25°C (77°F) are neutral.

The easiest method of measuring pH value is to use pH indicator paper – small paper strips that have been treated with a chemical compound that shows a different colour depending on the pH value. The result starts appearing as soon as the paper comes in contact with the liquid that you want to test so you can then compare the colour with the accompanying scale to read the pH value. If you use an indicator paper that tests from 0 to 14, you easily can assess whether your dye bath has the right pH value.

As the recipes in this book contain corrosive substances, make sure to always wear protective clothing, follow safety procedures and keep all such substances out of the reach of children.

Dry indigo pigment in cake form.

Dyeing with dry indigo pigment

Our recipes can be used for both synthetic and naturally produced indigo, but the vat can behave a bit differently depending on the quality of the indigo. A naturally produced indigo pigment will inevitably contain varying amounts of trace substances from the production process, like the sludge from plant sediment. In that case, the finished vat may not behave in the same way as we describe because of the trace substances it contains. There is no need to worry if the vat doesn't become bright green and transparent, for example, as some recipes indicate it might.

MAKING AN INDIGO PASTE Dry indigo pigment can be difficult to mix into water as it clings to the surface and doesn't want to sink, like cocoa powder in milk. To make the pigment easier to dissolve, we recommend making it into a paste first.

To do this, you mix the indigo with a small dash of methylated spirit or hot water in a small container until you create a paste. Stir the mixture with a spoon and use the back of the utensil to press the paste against the sides of the container to get rid of any grains and lumps.

INDIGO STOCK SOLUTION You can prepare a vat by mixing all the ingredients together in one go, but it's often better to mix the indigo pigment in a small amount of water to create an indigo stock solution measuring about 500ml/ 17fl oz. The stock solution is then dissolved into a blank dye bath consisting of water with added chemicals that control the oxygen level and pH value. The idea is that when you mix the indigo with a small amount of water, it's easier to ensure that the indigo reduces more efficiently and there are no clumps of undissolved indigo. Another advantage with using a stock solution is that it's easier to store for later use in case you don't use the whole amount all at once.

An indigo stock solution can be kept for a long time but it's important to make sure that you have the least amount of air in the jar. If your stock solution doesn't fill your container, fill it up with glass marbles until the solution reaches the brim, then close the lid and store at room temperature until the next time you're dyeing.

WATER BATH A water bath is usually the best method for keeping a stock solution warm, in order to accelerate the reduction. Place the jar into a larger vessel filled with warm water and add more warm water regularly. You can also heat a larger vat by lowering bottles filled with warm water into it.

Preparing the material

To get an even colour tone, you can soak the fabric or yarn before dyeing. The water in the textile will then help the indigo to spread evenly through the fibres. But you don't want to add too much oxygen-rich water into the vat, so it's good to squeeze out any excess water from the material before you dip it into the dye bath.

If you dip the textile that you're dyeing without soaking it first, the result will be more uneven, since air pockets will develop in the creases and in between the fibres. However, you may want to use that to your advantage to create beautiful patterns. The technique is especially striking when you dye yarn, since it will often soak up more dye on the outside of the thread than in the core.

If you are dying a fabric that hasn't previously been washed, we do recommend washing it first. This is because during the weaving, glue and other substances are added to make the process easier, something that can make it more difficult for the dye to fix onto the fibres.

Mix the pigment into a paste to make it easier to stir into water.

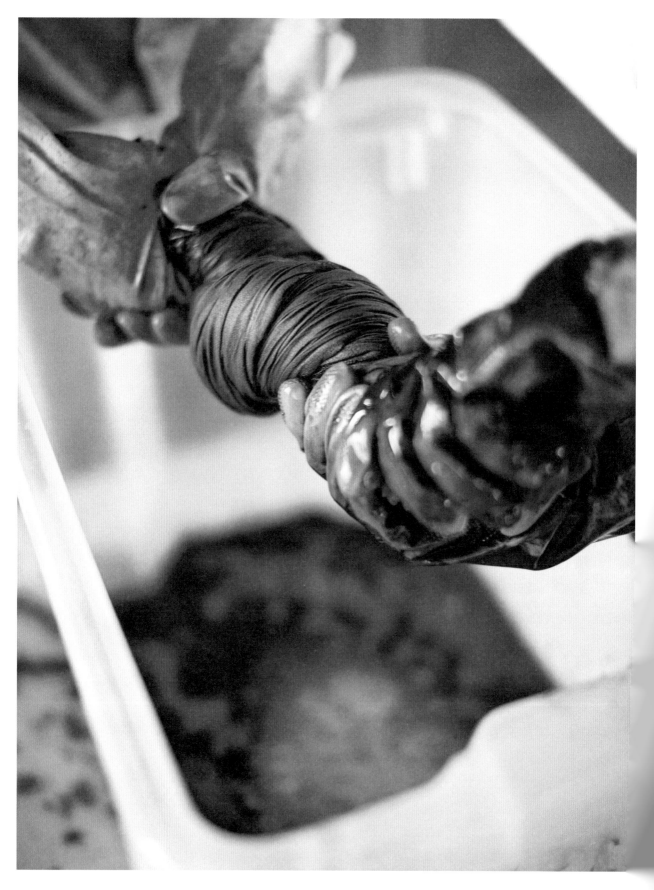

The excess dye is squeezed out in a separate vessel before the fabric is hung up and left to oxidize.

The dyeing stage

Make sure that the fabric you're dyeing is as smooth and flat as possible when it is lowered into the dye bath to avoid adding oxygen that will react with the indigo in the vat. If you are dyeing a garment, for example a pair of trousers, dip them feet first with the waist pointed upwards so that the air can pass through the legs as easily as possible. If you are dyeing yarn, start by scrunching it up into a small ball in your hand before adding it to the dye bath and then leave it to expand underneath the surface. Both fabric and yarn will get a more even result if you squeeze it in the vat while dyeing, but be careful to not stir down any oxygen into the vat. When the dye time is up, lift the material out of the vat and, again, try to do so by adding as little oxygen as possible. A good trick is to squeeze the material when just a small part of it is above the surface, as this way the dye goes back into the vat again without any splashing.

Wringing out the material in a different vessel

When you lift fabric or yarn out of a dye bath, your natural reflex is to hold it over the vessel and let excess dye drip down into the bath. It's not a good idea to do this when dyeing with indigo, since the dye that drips back into the vat will introduce oxygen that spoils the bath. Therefore, place a separate container next to the dye bath and wring out the textile over that. The collected excess dye can then be added back into the main dye bath and then sharpened by adding more alkali and reducing agent. This way, you can ensure that you don't waste any indigo pigment.

Oxidizing the indigo

When the fabric or yarn is taken out of the bath, it will be a greeny-yellow colour but as soon as it comes in contact with the oxygen in the air, the blue colour will start to appear in a process that's called 'oxidation'. In order to get an even coverage, make sure that all the fabric or yarn is in contact with the air. Skeins of yarn can be shaken and fabrics shouldn't be hung up too tightly. After approximately 15 minutes the oxidation process is complete! It's fine to wait longer before dipping again, or rinsing and washing, but the material shouldn't dry out completely without being rinsed first since the liquid in the vat is corrosive. Make sure the liquid doesn't come in contact with skin, eyes or mouth, and always wear protective clothing.

Repeated dips

To ensure that the blue dye fixes properly or to build up darker tones, the fabric needs to be dipped into the dye bath several times. The process can be compared to making candles; when it comes to candles, the wax needs to set in between each dip. In the case of indigo, the dye molecules need time to oxidize fully. There is no restriction as to how many times you should dip the material, but a good rule of thumb is to start with a minimum of four. Then the dye can be built up until you get the result you want, depending on how dark you'd like the colour. The first dip can be left for up to 15 minutes in the vat but the following dips shouldn't be left more than 5 minutes each, unless the recipe states otherwise. This is because the previous layers of indigo that have been built up so far will start to dissolve again when the material is lowered back into the oxygen-free dye bath. If the following dips are longer, the dye will start to dissolve instead of building up and the colour on the fabric will not get any darker than the first dip.

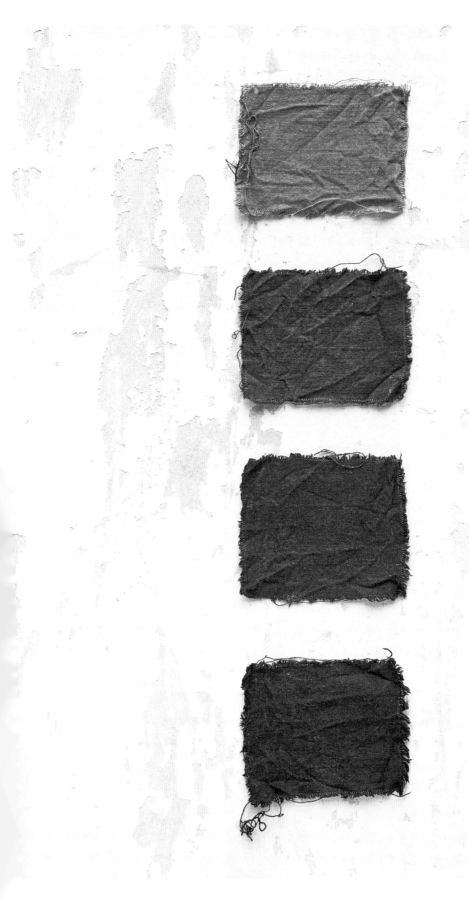

Fabric samples dyed with natural indigo dipped five, ten, fifteen and twenty times.

Tones

Remember that the tone of wet fabric will appear darker than when it's dried. The material will also contain a surplus amount of indigo that hasn't fixed and will therefore come off in the wash and rinse stage. If you get an inkling that the colour is right, it's a good idea to dip the material a few extra times to avoid disappointment when the finished result turns out lighter than you hoped.

Rinsing and washing

All dyed materials should be rinsed and washed thoroughly after dyeing, regardless of what kind of vat you've been using. A good rule of thumb is to always rinse the material eight times, with a little vinegar added to the last rinse. The acid from the vinegar will restore the fabric's pH balance after the alkaline dye bath. If the dyed material is left to dry without a proper rinse, there is a chance that it will get rough and brittle and that it will also irritate the skin. You can wash the textile without detergent in the washing machine as a final treatment, but remember to wash the indigo-dyed materials separately to avoid any other textiles turning blue. After a thorough rinse, you can go ahead and use the fabric; no other fixing is needed.

Indigo dye rubs off when dry, so don't ride bareback on a white horse in your new blue jeans just yet, cowboy! If you want to increase the colour fastness and the rubbing resistance of your fabric, you can make a soaping treatment by heating up the material in water at about 80–90°C (176–194°F) for an hour. With wool, you need to make sure you stir as little as possible during this process, and leave the material in the vessel as the water heats up and as it cools down. This reduces the chances of the wool felting.

Discarding a dye vat

Once you've finished dyeing there will usually be some liquid left in the dye bath. If you want to save the environment, your pigment stash and your wallet, you can store the dye bath for a few days by covering the surface with cling film (plastic wrap) to prevent any unnecessary oxygen seeping through. Often you will just need to sharpen the bath first by altering the pH value in order to continue dyeing. Simply warm up the vat to 50°C (122°F) and reduce the oxygen levels again.

Another way to make full use of the vat after dyeing is to have a piece of fabric or yarn that you always reuse in order to soak up any leftover pigment. The fabric will probably be light and uneven to start off with, but after some time this too will start to build up a nice blue tone.

Unfortunately dyeing with indigo is not completely harmless to the environment. Regardless of whether you're using chemicals or slaked lime to increase the pH value, the bath will need to be handled the right way after you've finished dyeing.

Vats that contain sodium hydroxide or sodium hydrosulfite are classed as hazardous waste and need to be taken to a household waste centre. Pour the liquid into a container that can be closed and make sure you label the container with the contents. This way you will minimize the risk of accidents and you will help those who work at the waste centre. It's important not to use a container that can be mistaken for containing something edible or drinkable.

Vats that contain lime and other natural ingredients can be flushed away into the drains. If the vat has a pH value over 7 after you've finished dyeing, flush it down with plenty of water so that the corrosive liquid is properly diluted. Liquids with unusually high or low pH value can cause corrosive damage on water pipes, boilers, pressure vessels and so on. Distilled vinegar can also be added to the bath before discarding to lower the pH value.

A vat made from fresh *Indigofera* before reduction.

Troubleshooting

Even when you have measured all the ingredients carefully and have prepared your dye bath slowly and steadily, it can happen that the vat doesn't behave exactly as you want it to. But don't panic, it's happened to all of us. You could look back to any number of historical excuses as to why it has not turned out as expected due to supernatural forces! For example, a poor hen could have walked too close to the dye bath and stolen the magic behind the blue colour. In Japan there is a long tradition of praying to a specific indigo god to ensure that the dye will perform as intended, so perhaps you did not say the right prayers. These examples mainly refer to dye baths with an active fermentation process that rely on developing a bacterial culture.

With today's chemical substances and tools, it's easier to control the efficacy of your vat. In the beginning it can be difficult, but the more time you spend on dyeing with indigo, the easier it will become to read the dye bath. Here are a few tips based on our experiences.

THE ULTIMATE VAT A properly reduced indigo vat is clear and free from dregs, unless it's a fermented vat in which case it should be opaque. A vat should not be dark blue, but could be red, yellow, blue-green or green, depending on what reducing process has been used. If the vat is blue, it means that the majority of the indigo hasn't been reduced and therefore won't be able to fix onto the fibres. A good trick is to lower a spoon just under the surface so that you can see the colour of the bath more clearly.

SHARPENING THE BATH Fabric that is dyed in a vat with non-reduced indigo can look very blue when the dyeing is finished, but during the rinse or the first washing, the dye comes off. One way to check if the indigo is reducing is to lower a white piece

of fabric into the bath for 5–10 minutes. If the fabric is greeny-yellow when you take it out of the vat and slowly changes colour to blue, the vat is healthy. If the fabric is partly or completely blue when it's taken out, it means a lot of the indigo that's in the bath is in a non-reduced form and needs to be reduced again, a process that is called 'sharpening the bath'.

To sharpen the bath, first check the bath's pH value. During the dyeing process it's common that the pH value decreases as you stir in more oxygen and therefore more alkali might be needed.

When that's done, the bath needs to be heated up to 50°C (122°F) and then you should add some more reducing substance. If the colour doesn't change once you've done this, cover it with a lid and leave the bath in a warm place for an hour or two. If you use sodium hydrosulfite to reduce the oxygen, it's useful to remember that this chemical has a short shelf life. Old sodium hydrosulfite that's been in contact with too much oxygen is less effective, so make sure you close the lid on the container immediately after you've measured the amount you need.

One way to decide whether the sodium hydrosulfite is in a good state or not is to CAREFULLY smell it. It should have a distinctive smell, but be careful not to breathe in the powder and not to get any in your eyes!

Fermented vats are sharpened by adding more organic materials so that the fermentation process can continue.

THE QUALITY OF THE PIGMENT Working with natural indigo can be a bit tricky. Once produced, the pigment contains a lot more than just pure indigo, and that means that natural indigo isn't as concentrated as synthetic indigo. Indigo pigment is a product that can easily be diluted without it being noticed, and there is plenty of historical evidence to say that this has happened, but it's difficult to know how common it is today. Unfortunately it's hard to know whether the concentration of pigment is good or not before you start the process of dyeing.

UNEVEN AND BLOTCHY RESULT If your fabric looks uneven or blotchy after dyeing, there can be several causes. It's good to make a habit of always washing a fabric before dyeing it. Regardless of whether it's a new fabric that comes directly from the loom or an old fabric that you've bought at a flea market, it can contain various impurities such as glue, fat and dirt. Fabric can also have a low pH value, which can affect the dyeing. This can also be prevented by washing it.

UNINTENTIONAL RESIST PATTERN The material that you have dyed could have been folded in the bath creating an unintentional resist pattern. To avoid this, it's a good idea to rinse the material before dipping it, and then squeeze and turn it underneath the surface of the vat so that the dye can permeate throughout the fabric. Remember not to splash the liquid in the bath to avoid stirring in oxygen.

SYNTHETIC FIBRES Another reason for blotchy dye results can be that the fabric or yarn that was dyed contains synthetic fibres that don't carry the same ability to soak up indigo dye, compared to natural fibres. Many newly produced fabrics and clothes contain, for example, a small percentage of lycra or acrylic that, when coloured, will appear as lighter details.

RINSING After dyeing, it's important to rinse the material thoroughly and repeatedly to remove the reducing substances. A sloppy rinse can result in the material bleaching. It is usually best to rinse thoroughly, then wash in the washing machine, to be on the safe side.

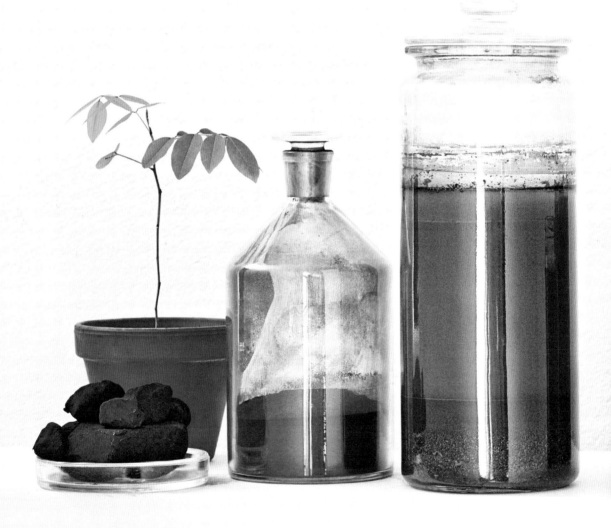

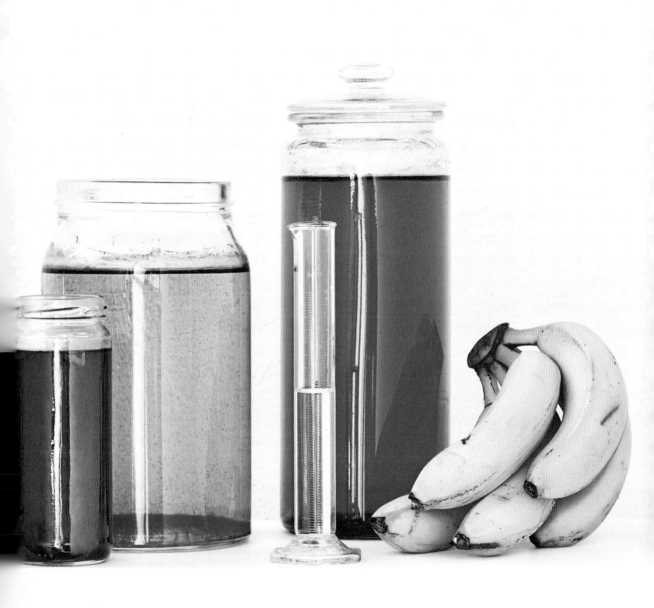

Resist dyeing using clothes pegs.

RECIPES

In this chapter there are recipes for different indigo vats. Some are ready in an hour while others can take several weeks to prepare. Some are kinder to the environment than others. Some describe how to use fresh plants while others use pigment as a starting point. There are recipes that are suitable for working with in a small apartment and others that are better tackled outdoors during warm summer months.

The vat's appearance and behaviour can vary from time to time. Regardless of how meticulous you are, it can be difficult to feel that you will ever understand the process fully. A large dose of curiosity and an appetite for trial and error are the two most important factors and we would also like to encourage you to experiment with measurements, times and temperatures.

If it's the first time you have dyed with indigo, we recommend that you read the chapter Dyeing with Indigo (see page 35) before you start, and you should also take a look at the safety information pages overleaf so that you are well prepared, as some of the recipes use caustic chemicals. Once you've done that, all you have to do is to take out your dyeing pot, roll up your sleeves and get started!

IN THE EVENT OF AN ACCIDENT

Some of the chemicals used in our recipes are hazardous for your health, so always work in a well-ventilated area and wear gloves, a protective mask and safety goggles when you handle them.

The following substances should be treated with the utmost care and be kept safely locked away and out of the reach of children. This list is not exhaustive, so always remember to follow package warnings. Medical attention should always be sought in the event of an accident.

SLAKED LIME (CALCIUM HYDROXIDE) is highly alkaline and corrosive. It can irritate the skin, your respiratory system, and cause serious eye injuries.

If comes in contact with eyes: Rinse carefully with running water for at least 15 minutes. Remove any contact lenses if it's easy to do so. Continue to rinse. Go to the hospital immediately.

If comes in contact with skin: Remove contaminated clothes and wash with soap and water.

If inhaled: Move the person to an area with fresh air.

If consumed: Do not induce vomiting. Rinse the mouth. Go to the hospital immediately.

SODIUM HYDROSULFITE (SODIUM DITHIONITE) is self-heating and can combust if it comes in contact with too much oxygen. This is mostly a concern for large volumes, but always close the lid tightly after use. Sodium hydrosulfite can cause chemical burns, serious eye injury and can damage your respiratory system. Spectralite (thiourea dioxide) can be used as an alternative, but only use half of the quantity specified in the recipe, as it is very strong and much more corrosive.

If comes in contact with eyes: Rinse immediately with running water for at least 15 minutes and hold your eyelids wide apart. Remove any contact lenses as quickly as possible and continue to rinse. Go to the hospital immediately.

If comes in contact with skin: Remove contaminated clothes and wash immediately with plenty of soap and water.

If inhaled: Move the person to an area with fresh air. Seek medical attention if you feel unwell.

If consumed: Do not induce vomiting. Rinse the mouth and then drink plenty of water. Go to the hospital immediately.

56

SODIUM HYDROXIDE (LYE, CAUSTIC SODA) is highly alkaline and therefore corrosive. It can irritate the skin and your respiratory system, and cause serious eye injury or blindness. When added to water, sodium hydroxide generates a lot of heat, so always add granules to water, never water to granules, as this may cause the resulting corrosive fluid to splash and burn you. Always use a heatproof, stainless steel vessel and a stainless steel or silicone spoon to mix the solution. Remember to always wear safety goggles, long sleeves, gloves and a protective mask and work in a well-ventilated area. Be careful not to breathe in any fumes. Vinegar can help neutralize any spillages.

If comes in contact with eyes: Rinse carefully with running water for at least 15 minutes and keep your eyes wide open. Remove any contact lenses if it's easy to do so. Continue to rinse. Immediately go to the hospital or see an ophthalmologist.

If comes in contact with skin: Wash with water.

If inhaled: Move the person to an area with fresh air. If breathing becomes problematic, go to the hospital immediately.

If consumed: Do not induce vomiting. Rinse the mouth immediately and drink plenty of water. Go to the hospital immediately.

SODIUM CARBONATE (SODA ASH, WASHING SODA) is a mildly caustic substance, so always wear safety equipment. For advice regarding accidental contact, see sodium hydroxide.

AMMONIA Concentrated amounts of ammonia are very corrosive. Ammonia gas is very irritating on eyes and mucous membranes and, if inhaled in large quantities, there is a risk of breathing problems and lung damage.

If comes in contact with eyes: Rinse carefully with running water for at least 15 minutes and keep your eyes wide open. Remove any contact lenses if it's easy to do so. Continue to rinse. Go to the hospital or see an ophthalmologist.

If comes in contact with skin: Wash with soap and water.

If inhaled: Move the person to an area with fresh air. If breathing becomes problematic, go to the hospital immediately.

If consumed: Do not induce vomiting. Rinse the mouth and then drink plenty of water. Go to the hospital immediately.

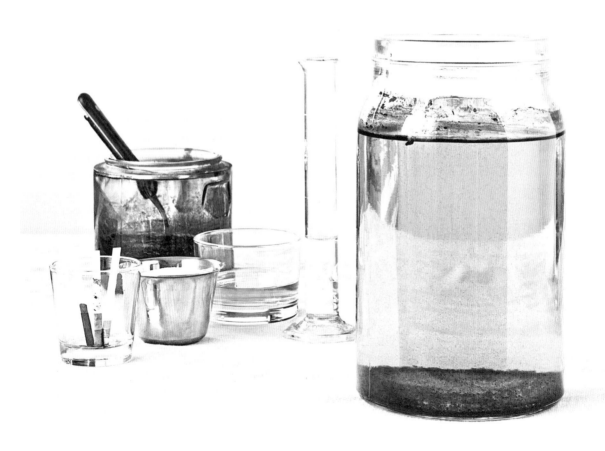

Dye bath for cellulose fibres that's ready to use.

GÖSTA SANDBERG'S HYDROSULFITE VAT

Designed for synthetic indigo dye, this vat is from Gösta's 1989 *Indigo Textiles: Technique and History*, the standard text in Swedish dyeing circles. This indigo stock solution can be used for two different kinds of dye bath given overleaf – for cellulose or for animal fibres. If you are dyeing with natural indigo, increase the amount of stock solution to the blank bath to compensate for the lower concentration of dye pigment.

59

RECIPES

Time
- *1–1½ hours*

Equipment
- *500ml/17fl oz lidded glass jar*
- *scales*
- *spoon*
- *stainless steel vessel*
- *protective mask*
- *plastic gloves*
- *safety goggles*
- *measuring beaker*
- *thermometer*
- *15-litre/26-pint heatproof dye vessel*

Ingredients
- *10g indigo*
- *methylated spirit*
- *180ml/6fl oz cold water*
- *3.75g sodium hydroxide*
- *10g sodium hydrosulfite*

INDIGO STOCK SOLUTION

In the glass jar, mix the indigo and a dash of methylated spirit into a paste.

In the stainless steel vessel, first add the cold water, then sprinkle in the sodium hydroxide while you stir. Remember to use a protective mask, gloves and safety goggles. Do not breathe in any fumes. The vessel may rapidly heat up, so place it on a heatproof surface. If the temperature exceeds 50°C (122°F), let it cool down for a while. Once mixed, you can add the solution to the indigo!

Weigh and sprinkle over the sodium hydrosulfite. This reduces the oxygen levels in the vat, therefore it's important to stir slowly and carefully so that you don't stir in any oxygen.

Cover with the lid and place the jar in a water bath at 50–55°C (122–131°F). Leave to stand for 30–60 minutes. It's good to stir carefully once or twice during this time. The colour of the stock solution will slowly change from dark blue to brown with yellow-green edges.

DYE BATH FOR WOOL AND SILK

TIME
— *20 minutes*

EQUIPMENT
— *15-litre/26-pint heatproof dye vessel*
— *spoon*
— *measuring beaker*
— *scales*
— *protective mask*
— *plastic gloves*
— *safety goggles*
— *thermometer*

INGREDIENTS
— *10 litres/ 17½ pints water at 50°C (122°F)*
— *2 sheets of gelatine*
— *100ml/3½fl oz warm water*
— *200g/7oz salt*
— *30ml/2 tbsp ammonia*
— *5g sodium hydrosulfite*

STOCK SOLUTION FOR VARIED RESULTS
— *10ml/2 tsp for light tones*
— *50ml/2fl oz for medium tones*
— *250ml/9fl oz for dark tones*

Add the 10 litres/17½ pints water to the dye vessel.

In a separate container, melt the gelatine into the 100ml/3½fl oz warm water. Stir thoroughly and make sure all the gelatine has melted or it can stick to the fabric and create stains. Add the gelatine solution to the dye vessel.

Weigh the salt, add to the vessel and stir.

Measure and add the ammonia. Remember to use protective mask, gloves and safety goggles.

Weigh the sodium hydrosulfite and add it by sprinkling it over the surface of the bath. Stir carefully.

Measure the amount of stock solution that you want to use and add. Stir carefully.

Now the bath is ready for dyeing. Keep it at 50°C (122°F) throughout the whole dyeing process.

For protein fibres, a maximum total dyeing time of 30 minutes is recommended to avoid the fibre becoming dry and brittle. The first dip can be left for up to 10 minutes, then the following dips should be 1–2 minutes long.

DYE BATH FOR CELLULOSE FIBRES

TIME
- *20 minutes*

EQUIPMENT
- *15-litre/26-pint dye vessel*
- *spoon*
- *measuring beaker*
- *scales*
- *protective mask*
- *plastic gloves*
- *safety goggles*
- *thermometer*

INGREDIENTS
- *10 litres/17½ pints water at 20–24°C (68–75°F)*
- *2 sheets of gelatine*
- *100ml/3½fl oz warm water*
- *200g/7oz salt*
- *0.5g sodium hydroxide*
- *2–3g sodium hydrosulfite*

STOCK SOLUTION FOR VARIED RESULTS
- *10ml/2 tsp for light tones*
- *50ml/2fl oz for medium tones*
- *250ml/9fl oz for dark tones*

Add the 10 litres/17½ pints water to the dye vessel.

In a separate container, melt the gelatine into the 100 ml/3½ fl oz warm water. Stir thoroughly and make sure all the gelatine has melted or it can stick to the fabric and create stains. Add the gelatine solution to the dye vessel.

Weigh the salt, add to the vessel and stir.

Measure and add the sodium hydroxide. If you do not have a scale that measures 0.5g, you can weigh your scales's smallest increment, then divide the pile into equal parts until each part is 0.5g. Remember to use protective mask, gloves and safety goggles.

Weigh the sodium hydrosulfite and add it by sprinkling it over the surface of the bath. Stir carefully.

Measure the amount of stock solution that you want to use and add. Stir carefully.

Wait for a few minutes until the dye bath is ready. The bath should be kept at 20 24°C (68–75°F) during the whole dyeing process. The first dip can be left for up to 10 minutes, then the following dips should be 1–2 minutes long.

BANANA VAT

Who doesn't have old brown bananas at home? In this recipe, you can salve your guilty conscience about the bananas that didn't get eaten (again). You just need two more ingredients: indigo and slaked lime. This technique has been developed by Michel Garcia who runs *Plantes et Couleurs* in France and who, among other things, produces textile dyes with organic pigments as a base. Michel travelled around North Africa in the 1950s and gathered information that he later used as a foundation when he developed this recipe. The result is a simple method based on ingredients that are easy to source, which makes this vat perfect for first-time dyers.

TIME
– *30–60 minutes*

EQUIPMENT
– *saucepan to boil the bananas in*
– *fork*
– *small bowl and spoon*
– *15-litre / 26-pint heatproof dye vessel*
– *mesh sieve or muslin*
– *scales*
– *thermometer*
– *pH indicator paper*

Mash the bananas with a fork in the saucepan. Add 2 litres/3½ pints of the water and boil for a few minutes.

Meanwhile, make a paste of the indigo with a dash of hot water.

Strain off the fruit bits from the boiled bananas and pour the liquid into the dye vessel.

Add the rest of the water to make it up to 10 litres/17½ pints water in total. Save the fruit pieces; they can be useful if you want to sharpen the dye bath later.

First weigh and add the indigo to the bath and then the slaked lime. Stir carefully 3–4 times, leaving a few minutes' gap in between. Small bubbles and a red shimmering film on the surface are signs that the indigo has started to reduce.

INGREDIENTS

- *650g / 1lb 7oz bananas, peeled (5–6 bananas)*
- *10 litres / 17½ pints water*
- *30g indigo*
- *20g slaked lime*
- *a little wheat bran*

63

Heat up the bath to 50°C (122°F). It can turn a green, brown or reddish tone but should look transparent above the layer of sediment once it has reduced. The process can take between 15 minutes and 1 hour, so now is the time for a coffee break!

The bath should now be ready for dyeing. The dipping times that are recommended here are unusually long: 15–30 minutes for cellulose fibres and up to 1 hour for protein fibres.

In the bottom of the vat, a layer of sediment will collect made out of fruit, slaked lime and indigo that hasn't reduced. If your goal with the dyeing is to get an even result without blotches, you need to be careful not to stir this up from the bottom of the bath. A good trick is to place the fabric that you're dyeing into a sieve and then lower that into the dye bath.

To sharpen the vat, you can boil the saved banana mash again (or use new bananas), strain the liquid and add it to the vat as a way of adding more sugar.

After dyeing, you can save the vat. It contains so much sugar and organic material from the bananas that it carries good potential for fermentation and the oxygen levels will then start to reduce again. Feed it with a little wheat bran, check that the pH value is constant at 8–9 and check regularly with test fabric to ascertain when the vat is ready for dyeing again.

Fresh woad being prepared for dyeing (see recipe page 74).

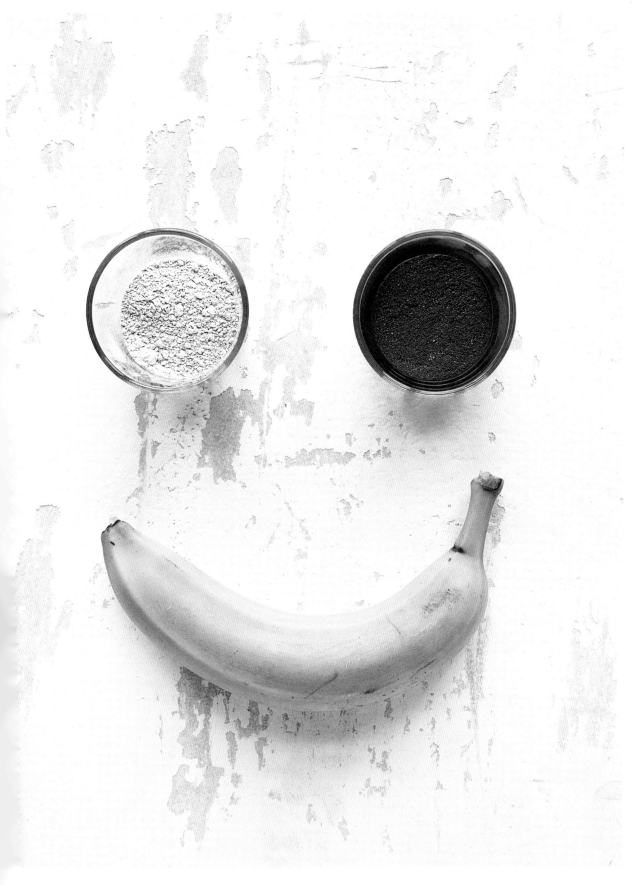

Slaked lime, indigo and banana (see recipe page 62).

FRUCTOSE VAT

Here is another recipe from Michel Garcia. Instead of bananas, pure fructose is used, which is easier to use and handy if you are dyeing a large amount of fabric. You can usually find fructose on the sugar shelf in large supermarkets. This method is simple and is also called the one-two-three method: one part indigo is mixed with two parts slaked lime and three parts fructose. If you stick to this ratio it's super-easy to scale up and down the measurements. You can also choose to use all of the stock solution or just a part of it, depending on what tone you'd like.

TIME
– *1½–2 hours*

EQUIPMENT
– *small bowl and spoon*
– *1-litre/1¾-pint glass jar*
– *scales*
– *thermometer*
– *7-litre/12-pint heatproof dye vessel*

INGREDIENTS
– *10g indigo*
– *5 litres/8¾ pints water at 50°C (122°F)*
– *30g/2 tbsp fructose*
– *20g slaked lime*

MAKE A STOCK SOLUTION

In the small bowl, mix the indigo and a little warm water to make a paste. In the glass jar, add 1 litre/1¾ pints of the water at 50°C (122°F) and the paste and stir.

Add the fructose and stir.

Add the slaked lime and mix well, making sure you don't stir in too much oxygen.

The bath should now appear yellow-green and cloudy. Leave to stand for 1 hour in a water bath (see page 40) and stir occasionally. After 45 minutes, give it a final stir and then let the sediment from the slaked lime and indigo sink to the bottom.

The stock solution is ready to use when all the sediment has sunk to the bottom of the jar and the liquid above the sediment is clear. The liquid could be yellow-green or brown, but it shouldn't appear blue. On the surface there should be blue bubbles and a copper-red film. If you don't see this, you can leave it in the warm water bath for a bit longer.

66

PREPARE THE DYE BATH

Pour the remaining 4 litres/7 pints of the
water at 50°C (122°F) into a heatproof
vessel.

Carefully add the stock solution, including the
sediment from the bottom of the jar. How
much stock solution you add depends on
how dark you would like your textile to be.

Stir the dye bath, then leave to rest for about
30 minutes. When the bath is yellow-green
with blue bubbles on the surface, it is then
ready for dyeing.

If the bath needs sharpening, you can do so
by heating it up to 50°C (122°F) and
adding a tablespoon of fructose. Then wait
for 30 minutes and check again to see if it
has turned yellow-green. If it hasn't, you
can try stirring in a little bit of slaked lime
and waiting for a little while longer.

WARM DYEING WITH JAPANESE INDIGO

Kaili Maide, gardener at Bergius Botanic Garden in Stockholm, dyes blue tones with fresh Japanese indigo using these methods.

TIME
- *5½–42 hours, depending on method*

EQUIPMENT
- *bucket or large saucepan*
- *plate*
- *sieve*
- *electric whisk or an extra bucket*
- *pH indicator paper*
- *thermometer*
- *plastic gloves*
- *safety goggles*

INGREDIENTS
- *fresh Japanese indigo leaves*
- *warm water at 50°C (122°F)*
- *5g sodium carbonate per 1 litre/1¾ pints water*
- *1 tsp sodium hydrosulfite per 1 litre/1¾ pints water*

Chop or tear the indigo leaves into smaller pieces and put them in a bucket or a large saucepan. Pour over enough warm water to cover the leaves and place a plate on top as a weight. Make sure that all the leaves are below the surface of the water.

The aim is to get a liquid that is brick red-brown. This can be achieved in four different ways:

Option one Place the bucket into a larger vessel filled with water at 50–60°C (122–140°F). Wrap the whole lot in a thick duvet or blanket and leave to stand overnight.

Option two Place the pan on the stove and keep the temperature constant at 50–60°C (122–140°F) for 4–6 hours.

Option three Leave the bucket of leaves to stand at room temperature for a few days until the bath has turned the right colour.

Option four If you have a compost pile with an average temperature of about 50–60°C (122–140°F), you can cover the bucket of leaves and bury it in the compost to keep it warm until the dye bath has turned the right colour.

When the leaf mixture has finished fermenting, the bath will be brown in colour and can appear blue-green at

the edges. Use a sieve to remove the
 leaves from the batch and press out the
 remaining liquid.
Add 5g sodium carbonate for every 1 litre/
 1¾ pints of liquid.
Whisk the bath with an electric whisk or pour
 from one bucket into another several times
 to introduce oxygen. Once the pigment
 has come in contact with oxygen, the
 colour of the water will turn to blue-green.
 Plastic gloves and safety goggles should be
 used, since the bath now is heavily alkaline.
 At this point, check that the pH value
 is between 9–10. If it is lower, you can
 sprinkle on some more sodium carbonate.
 Leave the bath to rest for 20 minutes.
Heat the bath to 60°C (140°F). Keep a close
 eye on it to make sure it doesn't boil.
Add 1 tsp sodium hydrosulfite for every
 1 litre/1¾ pints of water by sprinkling
 it over the surface of the bath. Carefully
 stir and leave the bath to stand for
 30–40 minutes. The liquid will turn
 yellow-green when it is ready for dyeing.

FRESH JAPANESE INDIGO WITH ICED WATER

The following recipe was created by Rowland Ricketts, who has spent several years studying the Japanese technique of growing and dyeing with Japanese indigo. The recipe is different from the others in many ways. Firstly, it only contains two ingredients, iced water and leaves from Japanese indigo (*Persicaria tinctoria*). Secondly, the leaves must be fresh. Preferably they should be picked and used immediately and therefore the recipe is only suitable for those who grow their own Japanese indigo. The plant will wilt quickly once picked, and as soon as it does, a process starts to break down the indican in the leaves. If you are not able to pick the leaves just before dyeing, the earliest you can do so is the evening before and then keep the leaves standing in cold water in a cool place to slow the breakdown process as much as possible.

The reason for using iced water is that the coldness halts the indigo's oxidizing process and, in this way, gives you more time for the dyeing stage, but you still have to get a move on. Once you've started the blender, you've got approximately 7–10 minutes to dye! Therefore you need to be well prepared and keep everything you will require close at hand.

The recipe given is suitable for dyeing approximately $1m^2/10ft^2$ of fabric (here, we recommend using silk) in a light blue tone. For a darker tone you will have to dye the fabric several times, in other words, mix together a new dye bath before each dip. This dyeing method is best suited to silk, which has a neutral pH value. After you've finished dyeing you can save the leaf mixture and use it again by making it into a reduced vat.

TIME
– *20 minutes*

EQUIPMENT
– *1.5-litre / 2½-pint blender*
– *fine muslin or mesh sieve*
– *3-litre / 5-pint bowl or bucket for dyeing*

INGREDIENTS
– *1m² / 10ft² silk*
– *2-litre / 3½-pint measuring jug loosely packed with Japanese indigo leaves*
– *enough cold water and ice to fill half the blender*

Soak the silk in cold water. Tear the leaves off the stalks, rinse and place them in the measuring jug with ice-cold water.

Have everything ready. The second you turn on the blender, the indican in the leaves will start to oxidize.

Fill a blender half full with water and ice. Fill with loosely packed leaves and blend for 1–2 minutes. Add more leaves as you go along until the blender is full of leaf mixture.

Immediately strain the mixture into a bowl or bucket used for dyeing to remove as many leaf bits as possible. It's a good idea to use a loosely woven fabric instead of a sieve, since the fabric will catch a lot more material than the sieve.

Add the silk to the liquid and leave for 3–5 minutes. It's likely that the fabric is too large to be laid flat into the dye bath, which is completely fine. Squeeze the fabric in the bath often to give the dye a chance to reach all the nooks and crannies to get an even result.

Remove the fabric from the bath, leave to oxidize, rinse and dry.

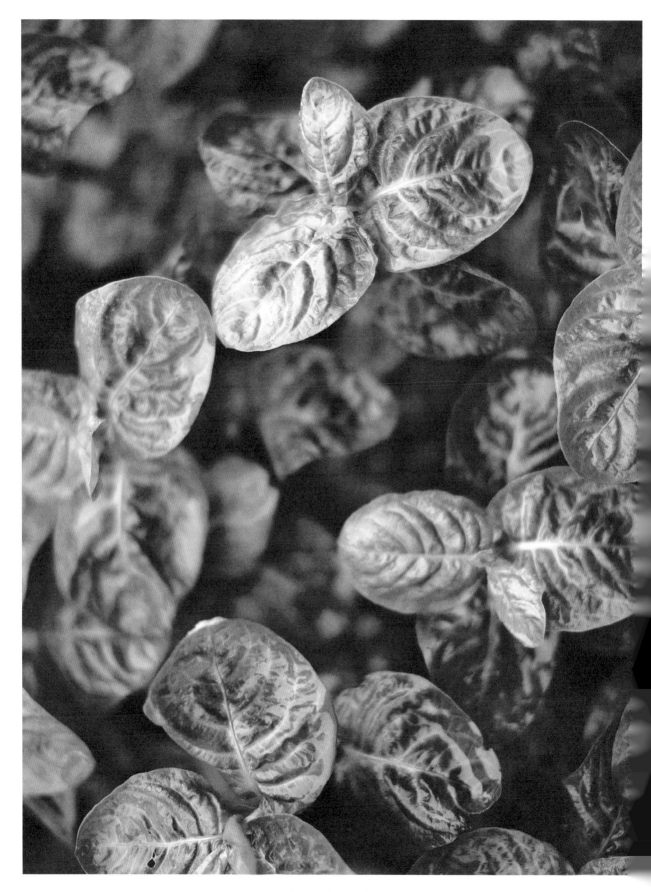

Round-leaved Japanese indigo.

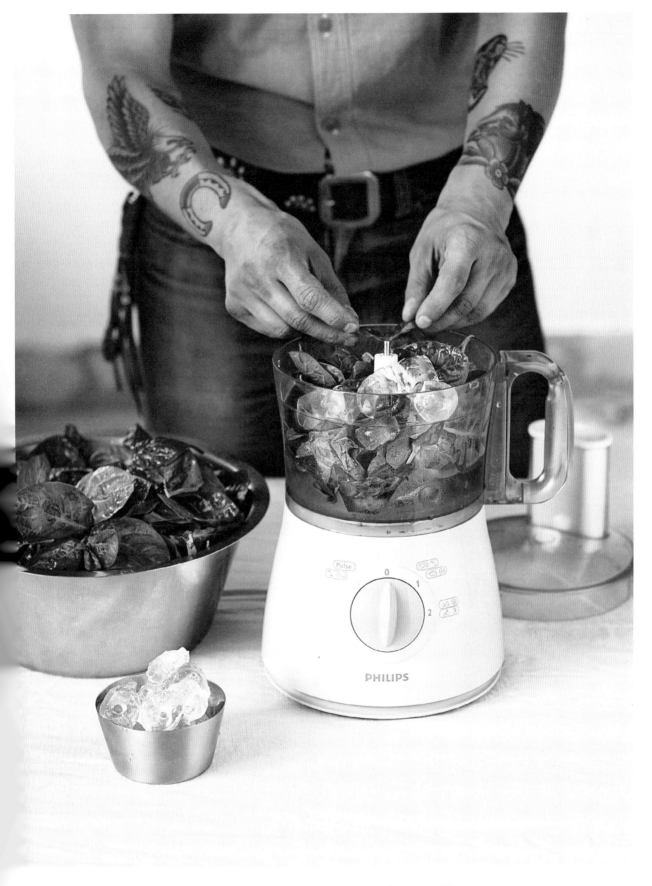

Fresh Japanese indigo with iced water (see recipe on page 70).

FRESH WOAD VAT

This recipe comes from Anna Vasko, who is active in natural dyeing circles in Finland. The recipe uses fresh leaves and, just like in the recipe for fresh Japanese indigo, the leaves should be used as soon as possible after they've been picked.

TIME
- *1½ hours*

EQUIPMENT
- *saucepan for dyeing*
- *fine muslin or mesh sieve*
- *two 10-litre/ 17½-pint buckets*
- *pH indicator paper*

INGREDIENTS
- *fresh woad leaves*
- *boiling water*
- *sodium carbonate*
- *5g sodium hydrosulfite per 1 litre/1¾ pints water*

EXTRACTING THE PIGMENT FROM THE PLANT

Chop or tear the leaves into smaller pieces.

Place the leaves in the saucepan and pour over enough boiling water to cover the leaves. Leave to stand for 40 minutes until the liquid turns a red colour.

Strain the saucepan to remove the leaves.

Add the sodium carbonate in small doses. Check the pH value regularly until it measures between 9–10 and the liquid turns green.

Pour the liquid from one bucket to the other several times to introduce oxygen until it turns blue. If you don't have time to dye straight away, pour the liquid into a jar with a tight-fitting lid and keep it at room temperature for a few days before continuing the dye process.

MAKING A DYE VAT

Pour the dye bath into the saucepan and heat up to 55–60°C (131–140°F).

Add the sodium hydrosulfite by sprinkling it over the surface of the dye bath and then stirring carefully. Leave to stand for approximately 30 minutes until the bath is reduced and has turned yellow-green. The dye bath is now ready to be used.

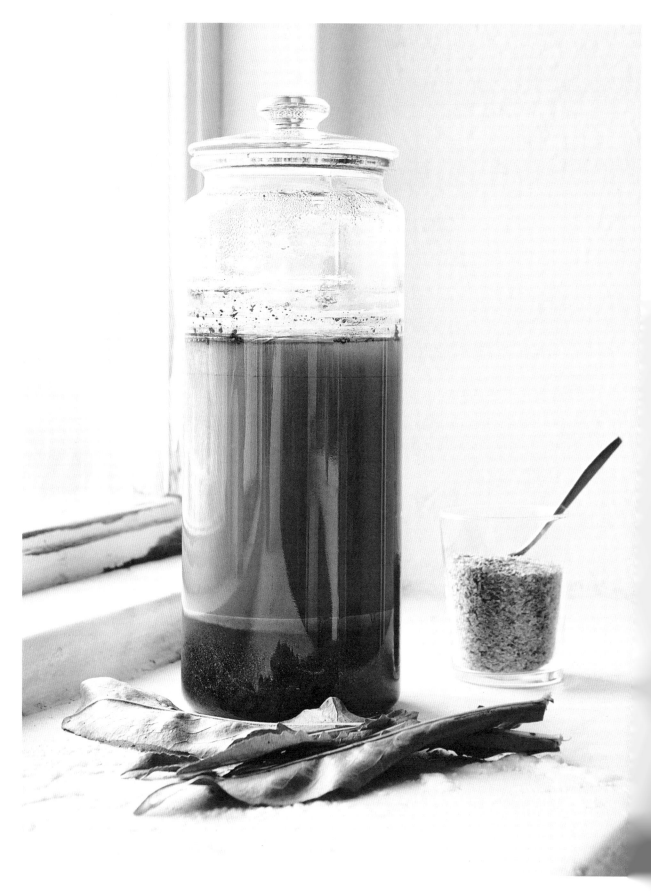

Fermented vat with wheat bran ready for dyeing.

Fermented vats

Fermenting an indigo vat is the oldest reducing technique and it's also the technique that will take the longest time to prepare. The advantage is once you've got a fermented vat going, you can keep it alive for a long time by adding more sugar and biological material, just like feeding sourdough bread.

In the fermentation process, yeast consumes both sugar and oxygen. This means that a liquid that is going through the fermentation process contains less oxygen than a liquid which is not fermenting, and you can use this to your advantage when you want to create an oxygen-free environment for the indigo.

You can ferment a vat with baker's yeast and a little sugar, or create a wild yeast with wheat bran and something sweet, for example a few dates or some common madder.

All fermented vats develop unique bacterial flora and will therefore behave a little differently. Even though a fermented vat takes longer to prepare and can seem a little more complicated than other techniques, a large part of the satisfaction lies in gaining a better understanding of the subject and, at the same time, knowing that you are dyeing in a natural way.

You can use indigo both from fresh plants and from dried pigment in a fermented reduction. If you choose to work with fresh plants, you start by extracting the indigo from them following the recipes for fresh Japanese indigo (see pages 68–71). If you've got leaves from another *Indigofera* species, you can prepare them in the same way as for fresh Japanese indigo.

If you want to ferment a dried indigo pigment, you need to make it into a paste as usual and then mix it into a larger amount of water. A good standard ratio to keep to is 6–8g of indigo per 1 litre/1¾ pints of water. The measurements given in this recipe are in general quite vague, since it's the actual fermentation process that does the job. Make sure the pH value is consistent at around 9 and the temperature is fairly warm. If you do, the size of the vat doesn't matter.

FERMENTED VAT WITH WHEAT BRAN

Jeanette Schäring has invested a lot of time in exploring bacterial flora in fermented vats and her work involves educating and spreading knowledge about natural dyes. She works in a field where the boundaries of craft, art and science are blurred, and has a philosophical approach to dyeing that is concerned with nature, the environment and sustainability. The following recipe is an example of how Jeanette would prepare a fermented indigo vat.

TIME
- *5–9 days*

EQUIPMENT
- *dye vessel with a tight-fitting lid*
- *pH indicator paper*
- *spoon*
- *thermometer*

INGREDIENTS
- *liquid with indigo solution from fresh plants or indigo paste dissolved in water*
- *slaked lime or wood ash lye*
- *30ml / 2 tbsp wheat bran per 1 litre / 1¾ pints water*

PREPARE THE DYE BATH

Add your pre-prepared indigo stock to a vessel with a tight-fitting lid. The liquid should be filled to the brim so that as little air as possible can fit in between the surface and the lid (see page 40).

Check the pH value and add slaked lime or wood ash lye until you reach a pH value of 9.

Add wheat bran and something sweet that contains antioxidants to start a fermentation process – honey, a few dates or some common madder work well.

The vat now needs to be left somewhere warm for 5–9 days to ferment at a temperature of 40°C (104°F). In summer, a greenhouse will keep the perfect temperature. In winter, the vat can be wrapped in a blanket and placed close to a radiator or another heat source. Stir the vat carefully at least once a day, but be careful not to splash down any oxygen.

The smell from an active and well-balanced vat should be damp and sweet, like decaying leaves in a forest, or a bog.

- *3 dates or 45g crushed common madder or 15ml / 1 tbsp honey per 10 litres / 17½ pints water*
- *water at 40°C (104°F)*

If the smell gets sharper, the bath can over-ferment, in which case, add some more alkaline material. If the fermentation process doesn't start, you can add a bit more of something sweet. When the vat is ready for dyeing it should be olive green and a bit cloudy; a shimmering copper film and small bubbles will appear on the surface.

To check whether the vat is ready or not, you can test it by dipping a piece of yarn or fabric for 10 minutes. When you take out the test patch, it should have a yellow-green colour, and slowly oxidize and turn blue.

DYE

All natural fibres can be dyed in this vat. Unwashed wool will work particularly well since it adds nutrients to the dye bath. Prepare what you want to dye by soaking it in water at the same temperature as the vat. Squeeze out any surplus water before you start to dye.

The actual dyeing process is similar to previous techniques: lower the material into the vat with as little splashing as possible.

The recommended dyeing times vary depending on the material and how the vat has developed. Start with a 5-minute dip and then experiment to see what works. When you've finished, the vat will need to recover. Feed it with some wheat bran and leave it to rest overnight and you'll soon be able to use it again.

Indigo in combination with other pigments

To soften, tint or completely change the classic indigo colour, you can combine it with other pigments. For example, a yellow fabric dyed with indigo can become green, and a red yarn can become burgundy, brown or purple depending on whether the base dye was a warm or cool colour. In order to achieve these colours, a common combination is to first dye a textile yellow with birch leaves and then overdye with indigo to get an intense green hue. If you want to combine indigo with a red pigment, common madder will give you brown to burgundy tones, while cochineal can be used to achieve purple tones.

Dyeing with plants that don't contain indigo is simpler in many ways. Basically, you can heat up material from the plants in water until they release their pigment. The yarn or fabric can then be added to the pan to soak up some of the pigment. Most plants will give a fairly pale colour unless the textile is treated with a mordant beforehand, which is recommended in most cases. The exception is certain lichens, heather and bark which contain substances that work as natural mordants.

A mordant is a substance that makes it easier for dye molecules to fix onto the yarn. In the following recipes, alum (potassium aluminium sulphate) is used. Those who want to try other mordant substances can experiment with black tea, iron rust, or oak galls, which are gall wasp nests made on oak leaves.

For all dye recipes, it's fine to experiment with the amount of dye in relation to the textile. A dye bath that you've used once can later be used again to give a paler tone. The dyeing time can always be extended and it's often a good idea to leave the textile in the bath while it cools, or overnight, to maximize the intensity of the colour. Compared to indigo, these dye baths are, in most cases, completely harmless for the environment and can be discarded straight into the drain or used as a fertilizer in your flower beds.

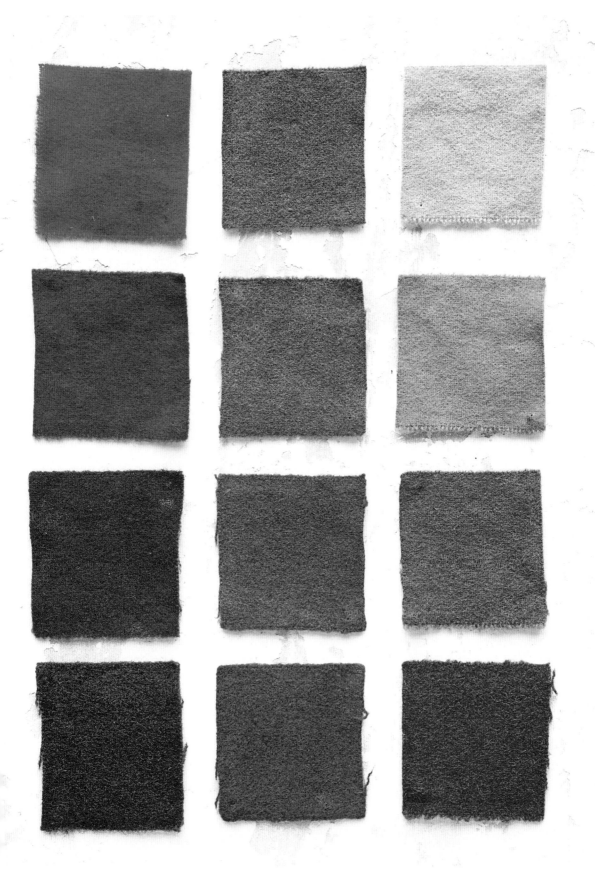

Wool fabric dyed with common madder (left), iron (middle) and birch (right) that's then been dipped in indigo once, then five and ten times.

DYEING COTTON AND WOOL WITH PLANT DYES

The recipes that follow are classic plant dye recipes for wool. Wool and cotton have a similar ability to soak up pigment when dyeing with indigo. However, this is not the case when dyeing with plant dyes dissolved in water. Plant dyes fix to wool and silk a lot easier than cellulose fibres, and cotton and linen that are dyed with recipes intended for dyeing wool will generally get a less intense result. For those who still want to try to dye cellulose fibres, we recommend using well-washed textiles: old sheets, for example. They will soak up the dye a lot easier than a newly produced fabric since the fibres are more worn.

MORDANTING WITH ALUM

Pre-treating the textile with alum increases its ability to soak up dye and fix it to the material. The colour tones will also become more vivid and intense.

TIME
— *1¼ hours*

EQUIPMENT
— *bucket for soaking*
— *saucepan*
— *thermometer*
— *spoon*

INGREDIENTS
— *fabric or yarn*
— *water*
— *150g / 5½oz alum per 1kg / 2lb 4oz fabric*

In the bucket, soak the textile in water at about 40°C (104°F).

In a saucepan large enough to comfortably hold the textile you want to dye, heat enough water to cover the material to about 40°C (104°F).

Add the alum and stir to dissolve.

Wring out the textile from the bucket, then add it to the saucepan. Leave it to soak for about 1 hour, keeping the temperature just below boiling. Stir a few times to avoid air pockets building up.

After 1 hour, take out the textile and rinse it in lukewarm water. The material can then be immediately dyed or dried to dye later.

YELLOW COLOURS WITH BIRCH LEAVES

Birch belongs to the Betulaceae family. The leaves can produce different colours throughout the year; in early summer, they give cleaner yellow tones and in late summer the colour can go a bit more yellow-green. You can also get a yellow dye by using brown onion peel, but the tone will turn dull and greyish if the textile is exposed to intense sunshine for a long period of time.

TIME
— *1–4 hours*

EQUIPMENT
— *saucepan*
— *sieve*
— *thermometer*
— *spoon*

INGREDIENTS
— *yarn or fabric*
— *1–2kg /
2lb 4oz–4lb 8oz
birch leaves or
500g / 1lb 2oz
onion peel per
100g / 3½oz fabric
or yarn*
— *water*

Mordant the fabric or yarn.

Place the leaves in the saucepan and top up with water until covered. Bring to the boil and leave to simmer over a low heat for at least 1 hour, preferably 3–4 hours.

Strain to remove the leaves, then add the textile. Keep the bath at 90°C (194°F) for at least 1 hour. Stir frequently, especially at the beginning, so that the dye reaches everywhere.

When you are happy with the colour, take the textile out and wash it, just like after dyeing with indigo.

RED COLOURS WITH COMMON MADDER

Common madder is a plant in the Rubiaceae family and is usually found in either ground or chopped form. To extract the pigment from the roots, you soak the madder in water overnight. Temperatures over 70–75°C (158–167°F) will soften the bright red colour and make it turn red-brown. In some recipes for indigo vats, common madder is listed as an ingredient. For these recipes, you can make the most of the plant and use it twice; on its own for dyeing to use up the pigment, and then again in a vat to use the plant's sugars to help develop bacterial flora.

TIME
— *2 hours to 2 days*

EQUIPMENT
— *saucepan or metal bucket*
— *thermometer*
— *spoon*
— *string bag*

INGREDIENTS
— *50–100g / 1¾–3½oz common madder per 100g / 3½oz fabric or yarn*
— *water*
— *30ml / 2 tbsp diluted distilled or white vinegar*
— *mordanted textile (see mordanting recipe on page 82)*

In a saucepan or metal bucket, add enough water to the pre-soaked common madder to allow the fabric you want to dye to float freely in the dye bath. Heat the temperature according to the result you'd like: for bright red tones the temperature shouldn't go over 70°C (158°F), for brick red you can go up to 80°C (176°F) and for red-brown 95°C (203°F) is good. Keep the saucepan's temperature constant for 1 hour to extract as much pigment as possible.

The dye bath is now ready to be used. If you use chopped madder to dye yarn, put the yarn in a mesh bag so the roots don't get tangled in the fibres. Put the material in the bath and leave it for at least 1 hour. Stir often and keep the temperature as constant as possible. Leave the yarn to cool in the bath overnight for an intense colour tone.

Rinse thoroughly after dyeing to remove any excess dye. In the last soak, add the vinegar to give an extra lustre.

RECIPE FOR IRON AND TANNIN

If you want a cloudy grey-blue indigo dye you can try dyeing the textile grey first by letting an ingredient that is rich in tannins (for example, black tea, acorns or pomegranate peel) react with iron, and then overdye with indigo. A simple way to prepare iron water is to leave an iron object to rust in a jar of water until the water turns orange. It can take anything from a couple of days to a couple of weeks, depending on the amount and the condition of the iron scrap that is used. Mould can build up on the surface, which you can easily pick off, but be careful not to breathe in any of the mould spores.

TIME
— *3–5 hours*

EQUIPMENT
— *saucepan*
— *muslin or sieve for straining*
— *thermometer*

INGREDIENTS
— *30g / 1oz black tea, crushed acorns or pomegranate peel per 100g / 3½oz fabric or yarn*
— *iron water*

Boil the tea, acorns or pomegranate peel in enough water to cover your textile for 1–3 hours.

Add the fabric or yarn. For an even colour tone and to avoid a blotchy result, you can strain the plant parts before the textile is added. If instead you'd like a more definite pattern, you can wrap the fabric or yarn around the tannin-rich ingredient before it's lowered into the bath. Heat the saucepan and its contents to around 90°C (194°F) and leave to stand for 1 hour.

Take out the textile and rinse it.

Add the iron water to a clean saucepan and heat up to 90°C (194°F). Lower the material into the water and leave for 1 hour. If you want an even result, you should stir a few times during the dyeing.

Take out the material and leave to oxidize in the air before rinsing and washing.

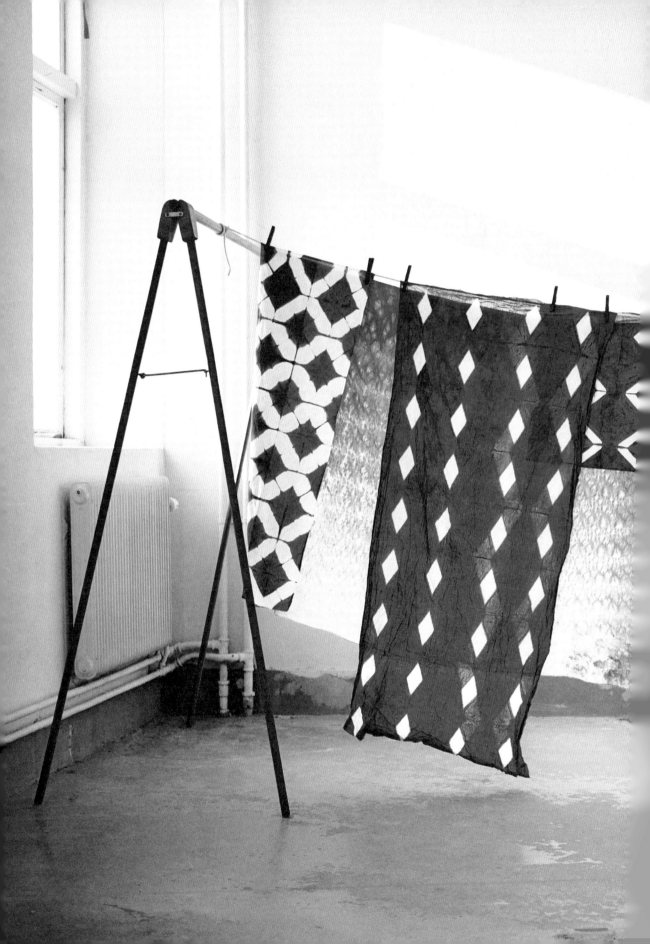

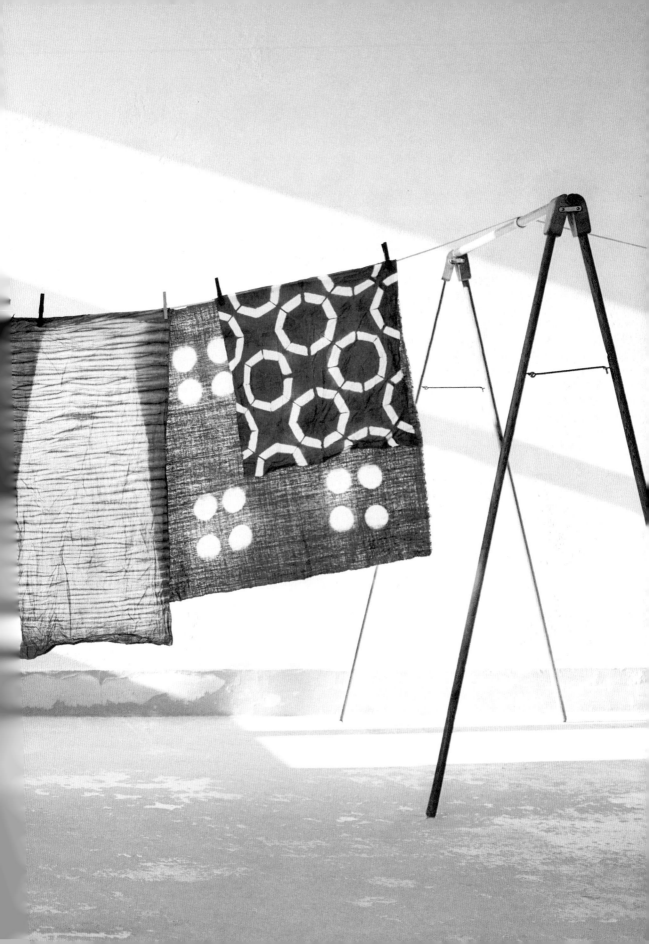

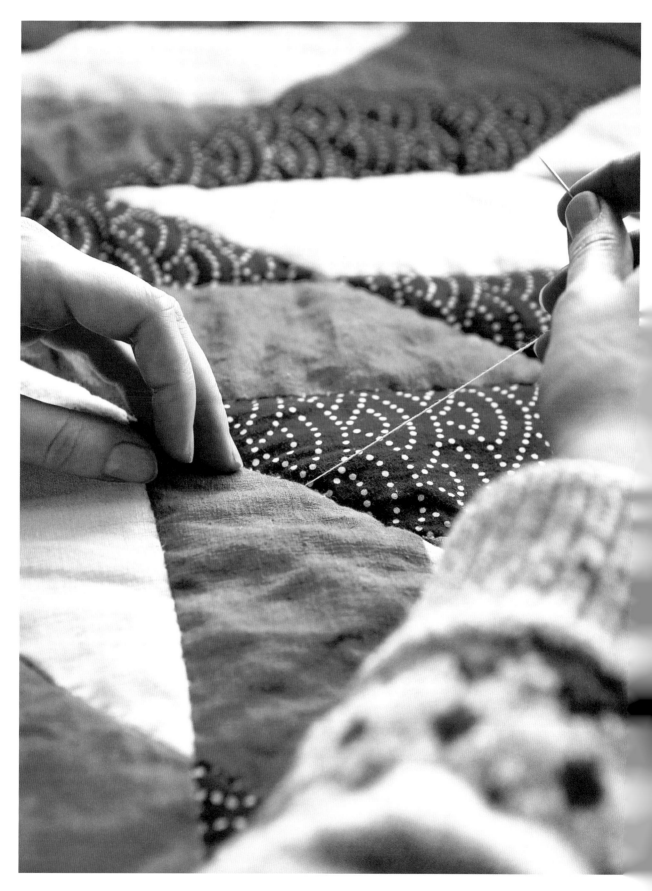

Kerstin working on a patchwork quilt.

PROJECTS

Once you've learned how to go about preparing a dye bath, the next step is to have a think about *what* it is you'd like to dye. There is a whole world full of traditional crafts that involve indigo and we have gathered together a few projects here in the hope of sparking an interest for the dye's many possibilities. Some projects are based on resist-dyeing techniques, some focus on sewing patterns that are both reinforcing and beautiful, and others emphasize sustainability in the form of patching and mending. One thing that they all have in common is that they become very beautiful if you use indigo-dyed materials but, of course, they will work with other colours as well. In this chapter we merely skim the surface of the subject but hopefully you will find inspiration here for your own projects.

Last but not least – rules are there to be broken!

Shibori

Shibori is the umbrella term for different Japanese resist-dyeing techniques. The art is ancient and is regarded as a traditional craft. The technique involves binding, sewing, folding, twisting or pressing a fabric to hinder dye from reaching parts of the fabric when it's dipped into the dye bath.

Shibori and *batik* are two different words that describe the same type of process. Historically, *batik* is focused on resist-dyeing techniques where wax or another viscous paste is used to create patterns, although the word is now sometimes used as a collective term for all types of resist dyeing.

When you work with *shibori*, the density and structure of the fabric are important – the denser the weave, the more difficult it is for the dye to reach through several layers. We prefer to work with thin fabrics made from silk or plant fibres, since they are the easiest to make clear patterns on.

After dyeing, it's best if the fabric is left to oxidize properly with the resist tools still attached. If it's folded into several layers and is held together with clips, for example, separate out the fabric as well as you can to make sure the oxygen reaches the whole piece. Another trick is to oxidize the fabric under running water. The oxygen in the water will help the indigo turn blue and it will penetrate more deeply into the fabric. After the first oxidization, you can continue to dip the textile several times into the dye bath until you are happy with the tone, then after the last dip you can remove the tools for the final oxidization. This way you ensure that the oxygen reaches all of the fabric.

One reason why it's such fun to experiment with resist-dyeing techniques is that it's difficult to predict the end result. Small changes in the fabric's texture, how a clip is placed, how the fabric is folded or handled in the dye bath can mean big differences to the result, making every pattern unique. There is something calming about letting go of control of the outcome.

1. Roll the fabric around the rope and secure it with a piece of string to keep it in place.

2. If you leave the scrunched up ring to float on the surface, the fabric will turn stripey.

3. It's easier to roll up large pieces of fabric onto a rope if there are two of you.

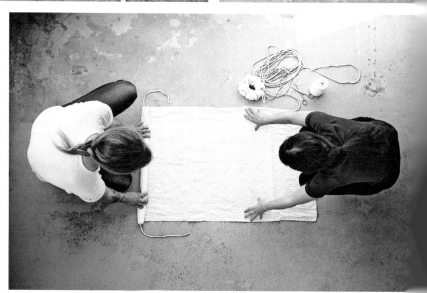

HONEYCOMB *SHIBORI*

This technique is simple, fun to prepare and will result in an exciting and detailed pattern. The colour changes appear because the fabric creases randomly and every result will be unique, but have a distinct, repetitive pattern. What's even better is that it's quick to prepare. In fact, the technique is so easy that we've heard it being called kindergarten *shibori*! If you roll the fabric tightly, the pattern shapes will be smaller and sharper, and the chance to get one end that's completely blue and one that's completely white increases. If you roll it loosely, the indigo can spread more easily in between the fabric layers and the pattern will become a bit softer and more diffuse.

— *a piece of fabric*

— *rope*

— *string*

Roll the fabric around the rope. Take the string and wind it loosely around the fabric sausage to keep it together so that it doesn't roll back again. Tie a knot at both ends. Make sure you don't wind it too tight. Scrunch the fabric up along the rope and tie both ends of the rope together, so you get a ring.

Now it's time to dye! Sometimes the fabric that's furthest in won't soak up any dye. If you want the colour and pattern there as well, you can roll the fabric again in the same way, but with the white facing outwards, and dye again. If you do, leave the fabric to oxidize, rinse and dry before doing the second round of dyeing.

Another alternative is to fold the fabric in the middle before rolling it up on the rope so that the folded end is the furthest in when rolling. This will make the fabric lighter in the middle with darker edges.

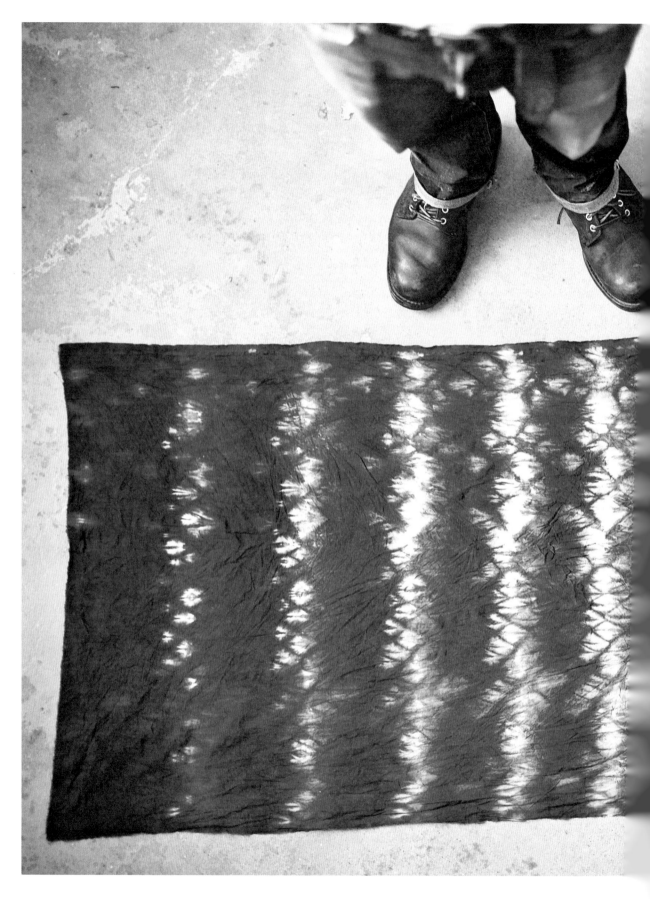

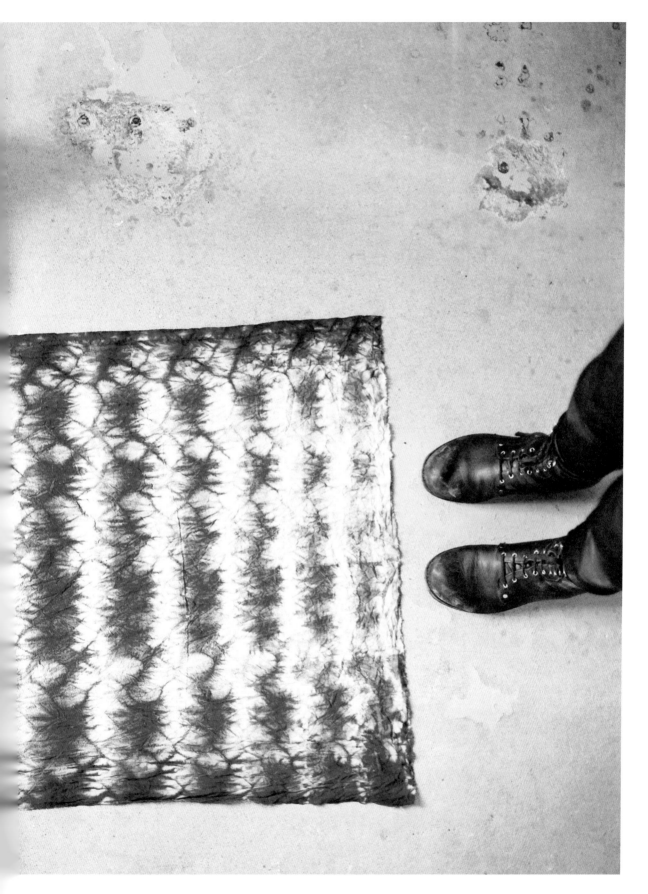

Honeycomb *shibori*.

1. Wind the string fairly loosely around the fabric, or it will be difficult to scrunch it down the pipe.

2. The advantage of a large pipe is that it can stand on the bottom of the pan.

3. Be careful that you don't cut a hole in the fabric when you remove the string.

ARASHI SHIBORI

The word *arashi* means 'storm' and it's a suitable name for this dramatic pattern. The method is similar to honeycomb *shibori*, but the difference is that you wrap the fabric around a hard object with a larger diameter. The result is an elongated pattern that is said to be reminiscent of stormy rain. This type of *shibori* demands quite a bit of preparation, but once you've folded out the fabric, it's worth the effort. According to the Japanese tradition, the fabric is wrapped onto long wooden poles but a large plastic pipe will also do the job.

— *a piece of fabric*

— *a pipe*

— *tape*

— *string*

Start by wrapping the fabric around the pipe. For an even result the fabric shouldn't wrap around itself, since the bottom layer would then be dyed in a lighter colour than the top layer. Fasten the fabric with a few bits of tape to keep it in place and wrap a piece of string over the fabric and around the pipe. Tighten the string carefully so that the fabric is held into place, but not so tight that it will make pushing it down difficult.

Remove the tape and press down the fabric so that it's gathered at one end of the pipe. Now you can dip the end of the pipe into the dye bath.

Fabric prepared for *itajime* dyeing.

ITAJIME SHIBORI

Itajime is a technique where you fold a piece of fabric and then press it between two objects. The area that's covered will remain undyed in the dyeing process. We sawed a piece of thin wood and drilled holes for wing nuts to make *itajime* clamps, but woodworking clamps, rubber bands or string works just as well.

The *itajime* techniques we show involve folding the fabric into a wedge or square. We started with a piece of fabric that measured 40 x 70cm/16 x 28in. First fold the fabric twice so you have a strip measuring 10 x 70cm/4 x 28in. Then fold it into either a square or a wedge. Turn the fabric over in between each fold as though you were creating an accordion and not a roll.

— *a piece of fabric*
— *strips of wood and nuts and bolts; alternatively use clamps, clothes pegs, rubber bands or string*

Start by rinsing the fabric and then fold it. The way you fold the fabric will affect the pattern, so try to visualize what you'd like the end result to look like and then think about the best way of folding. It's a good idea to try several different folding techniques to find the one you like the best. (See overleaf for examples of different patterns.) Then attach one or several clamps to create the pattern. Now you are ready to dye.

You can also create patterns with several different indigo tones by dyeing your *itajime* once and then moving the clamp to another position before dyeing it again. After the first dip, leave the fabric to oxidize for 15 minutes with the clamp in place before moving it and dipping the fabric again.

PROJECTS

100

Examples of *itajime* techniques, in which a clamp is placed on the folded fabric
before it is dyed. The illustration beneath each shows the resulting pattern.

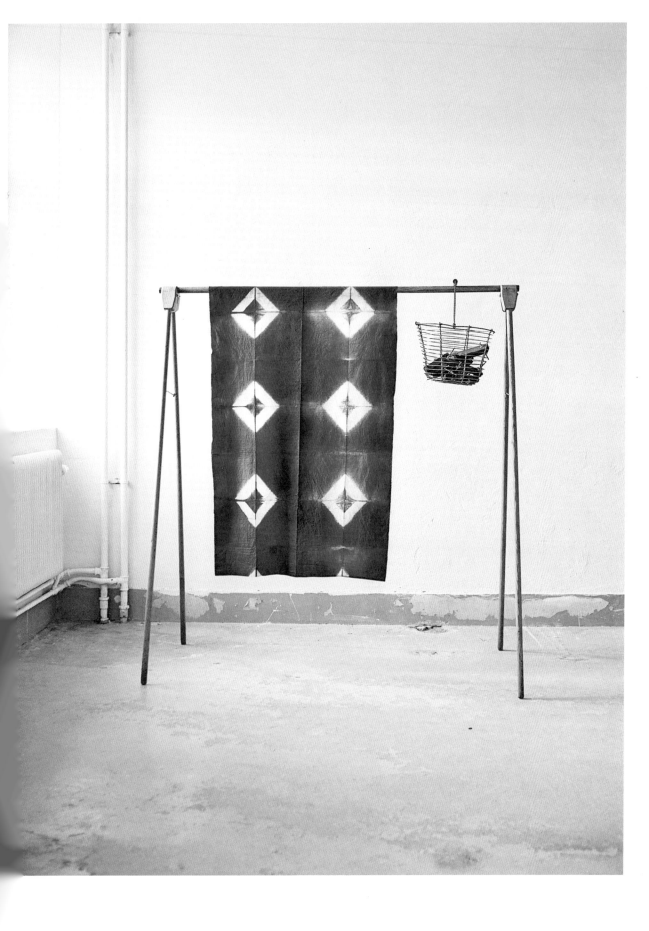

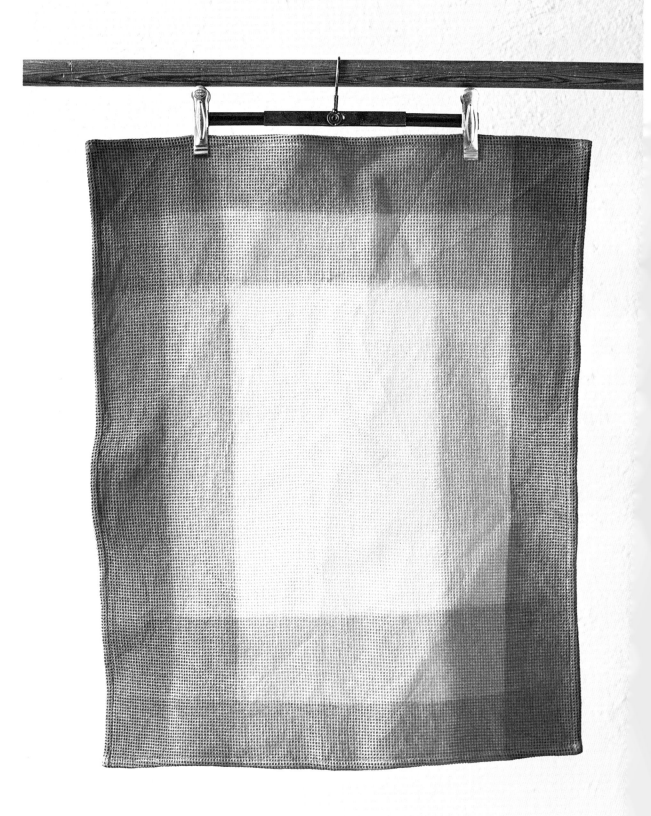

GRADUAL COLOUR TRANSITIONS

Building up darker tones of indigo requires multiple dips into the vat. Here we have used that to our advantage by dyeing different parts of a towel for different lengths of time to create a pattern.

- *ruler*
- *tailor's chalk*
- *sewing pins*
- *vessel for dyeing, as wide as the longest side of the fabric*
- *a wooden pole for hanging the fabric on*

Start by drawing the pattern on the wrong side of the fabric using a ruler and tailor's chalk. Place pins at the edges to make it clearer where the line begins and ends, since the chalk can be hard to see after a few dips.

Dampen the fabric until it's wet throughout before you dip it into the dye bath. This is to prevent the fabric soaking up dye above the chalked line.

Place the wooden pole over the edge of the dye vessel and hang the fabric so that one of the marked areas is dipped into the bath, with the chalked line aligned with the surface. Leave to soak for 5 minutes. Carefully lift out the fabric and leave it to oxidize for at least 10 minutes. Repeat until all the areas have been dyed.

Sometimes heavy fabrics tend to float up and lay themselves across the surface of the dye bath, which can result in an uneven pattern. Solve this problem by tying or attaching something heavy to the bottom of the fabric.

When the dyeing is finished, rinse and wash the fabric as usual.

These illustrations show how you can dip a textile to create gradual colour transitions,
as on the towel on page 102.

Examples of how you can create pattern variations in different colour
tones by dipping.

Moyo-sashi.

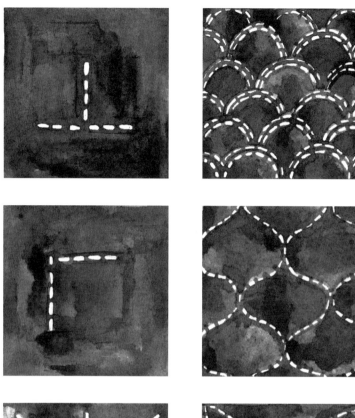

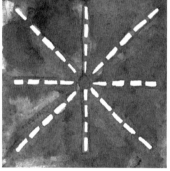

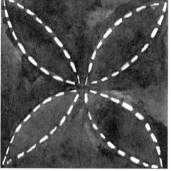

How to embroider *moyo-sashi*.
1. A new line should preferably start in between two stitches.
2. In a corner, a stitch is sewn right to the edge of the intended design before the line is turned.
3. Always leave a gap where many lines meet.

1. Ocean waves.
2. Fish net pattern.
3. Seven treasures.

Sashiko

Sashiko is a Japanese word for an embroidery technique that is used to reinforce, mend or stitch together one or several layers of fabric. The technique involves sewing different shapes in running stitch. Traditionally, *sashiko* is sewn using white thread made out of cotton or hemp onto a blue fabric, but nowadays you can buy special *sashiko* thread in many different colours. If you can't get hold of *sashiko* thread you can use another thick thread; we like to use flax thread 16/2, for example. When you sew, don't pull the thread too tight, since that can result in the fabric becoming crumpled.

Sewing with running stitch is not a technique that is specific to Japan, but in the 18th century a regulation came into place that prohibited Japanese farmers and fishermen from wearing clothes made out of cotton or that were brightly coloured. Additionally, they weren't allowed to embroider their clothes with stitches larger than a grain of rice. This regulation meant that special patterns and approaches developed and resulted in what we today call *sashiko*.

Since clothes made out of wool were very uncommon in Japan during this period, the people were restricted to clothes that were mainly made out of hemp, which doesn't warm as well as cotton. In northern Japan, where the winters are cold, people soon came up with a way to circumvent the ruling – if you weren't allowed to use cotton fabric you could still embroider the hemp fabric with cotton thread that gave both strength and warmth, establishing the *sashiko* embroidery tradition.

In modern *sashiko*, there are three main branches: *moyo-sashi*, *hitome-sashi* and *kogin-sashi*. We have chosen to focus on the first two.

MOYO-SASHI: ASA-NO-HA,
THE HEMP LEAF PATTERN

Moyo-sashi is usually what comes to mind when we talk about *sashiko*. The principle behind *moyo-sashi* is embroidering lines that together create patterns. To create a harmonious effect, the stitches should neither meet nor cross each other.

Using tailor's chalk and a ruler, you can sketch the pattern onto the fabric. Once you have done that, it's easy to stitch, as it is made up of simple lines that together form geometric patterns. The pattern symbolizes hemp leaves. Hemp is regarded as a cultural plant in Japan and has traditionally been used for making fabric and paper. It was also often used when decorating and strengthening children's clothes and the idea was that the child, just like the hemp, would grow up strong.

You can also choose to leave the *asa-no-ha* pattern incomplete, to leave something for the eye to work with. We think there is beauty in the temporary and unfinished, regardless whether it occurs in a handmade bowl, a worn material or an embroidered pattern.

- *fabric*
- *tailor's chalk*
- *ruler*
- *needle*
- *thread*

Start by drawing your pattern. Make sure you press hard with your chalk and use a colour that can be seen against the fabric, since chalk has a tendency to brush out. A tip is to start drawing the vertical lines first, followed by the diagonal, then fill in the gaps.

Now you are ready to start stitching. It's easiest to start with the straight lines and then fill in the gaps with the angled lines. Soon you will see the pattern take shape as the fabric becomes stronger.

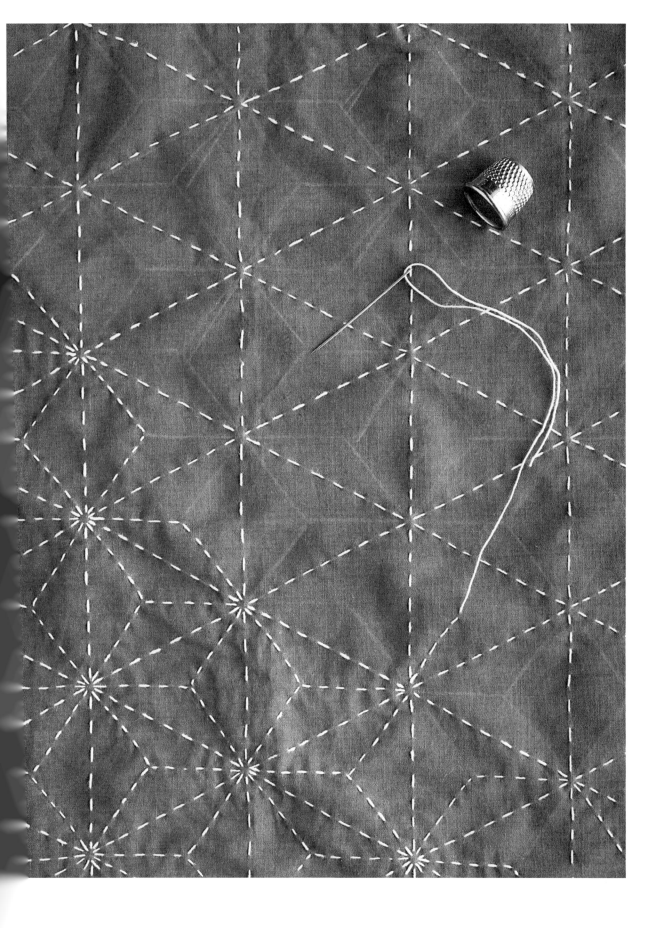

HITOME-SASHI: KAKI-NO-HANA, THE PERSIMMON FLOWER PATTERN

Hitome-sashi is a technique combining grids of stitches to create a repeat pattern. The stitches can cross and meet each other and both the stitches and the spaces between them are of equal length. *Hitome-sashi* is sewn over a framework of points that is usually marked up on the fabric before you start stitching. You can also count the threads in the fabric to work out a grid. The pattern is created by sewing the stitches in rows. First you make all the vertical stitches, then the horizontal.

- *fabric*
- *stencil, for example squared paper with holes in it*
- *tailor's chalk or pencil that is visible on the fabric but that can be washed off*
- *ruler*
- *needle*
- *thread*

Mark up a grid onto the fabric. You can either prick holes into a squared paper with a pin, place it on top of the fabric and then mark with a pencil in the holes on the wrong side of the fabric, or you can mark up a grid on the fabric using a ruler.

First sew all the vertical stitches. Think about how you want the final pattern to appear and make sure that all stitches are put in the right place in relation to each other. Then continue with the horizontal stitches. The gap in between the stitches should be the same length as the actual stitches.

Variations of *hitome-sashi* patterns.
1. Simple basic stitch. 2. Four basic stitches together. 3. The persimmon flower pattern. All stitches are of equal length and sewn with one-stitch-long gaps.

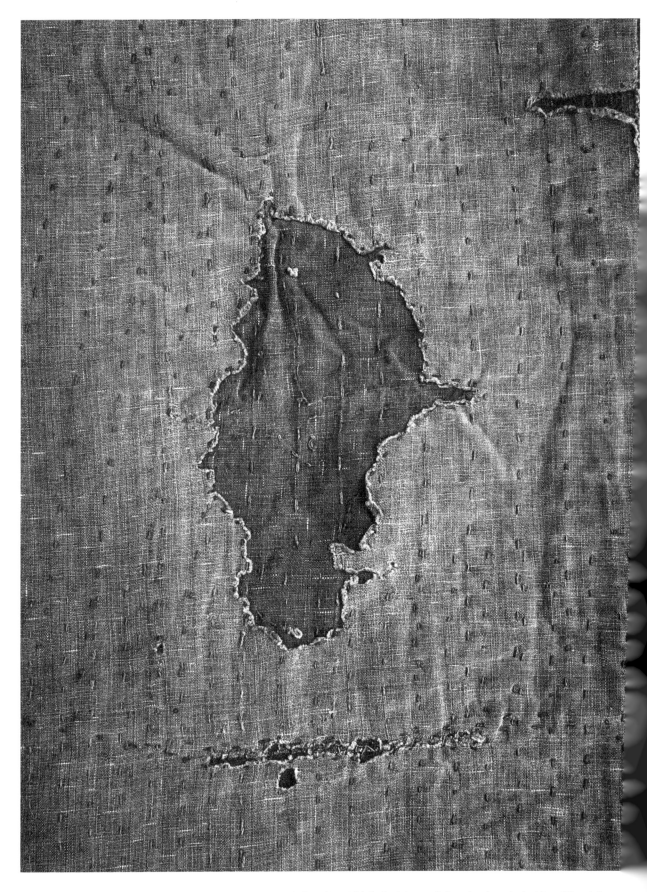

Detail of a pair of Japanese work trousers, called *monpe*, made from *kasuri* fabric that's been reinforced and patched with *sashiko* stitches.

Patching and mending

The skill of how to take care of and mend clothes seems to have almost disappeared within the space of a few generations. For most of us in the Western world it's now a choice and not a necessity to mend our clothes. If you think it's a shame to throw away a pair of jeans that are still serviceable apart from a hole on the knee, you can patch them up. This can be done in a few different ways; either by making the mend as invisible as possible or, alternatively, by letting the mend be visible and allow it to show traces of the person who wore the item. There can be beauty in a garment that's been owned and worn for a long time, as it tells the tale of everyday life.

BORO inspires us very much. It is a Japanese word that describes patched and mended garments and home textiles that have been predominantly developed out of necessity. These garments come from a time when you had to care for your possessions by adding new patches that were carefully attached with hand-sewn *sashiko* stitching. The technique was developed in the north of Japan and goes back several hundred years. The climate in those northerly areas isn't favourable for growing cotton, but the warming qualities of cotton were necessary for protection against the cold. The shortage of cotton resulted in people carefully looking after what they had and fabric scraps became a sought-after commodity. With *sashiko* stitching, patches were sewn on in several layers so that the material, the thread and the embroidery together built up warm and durable clothes.

Today *boro* textiles are regarded as valued antiques. In a society where it's easy to buy mass-manufactured textiles, the hunt for what feels authentic becomes a challenge, as the history becomes a part of the product's value.

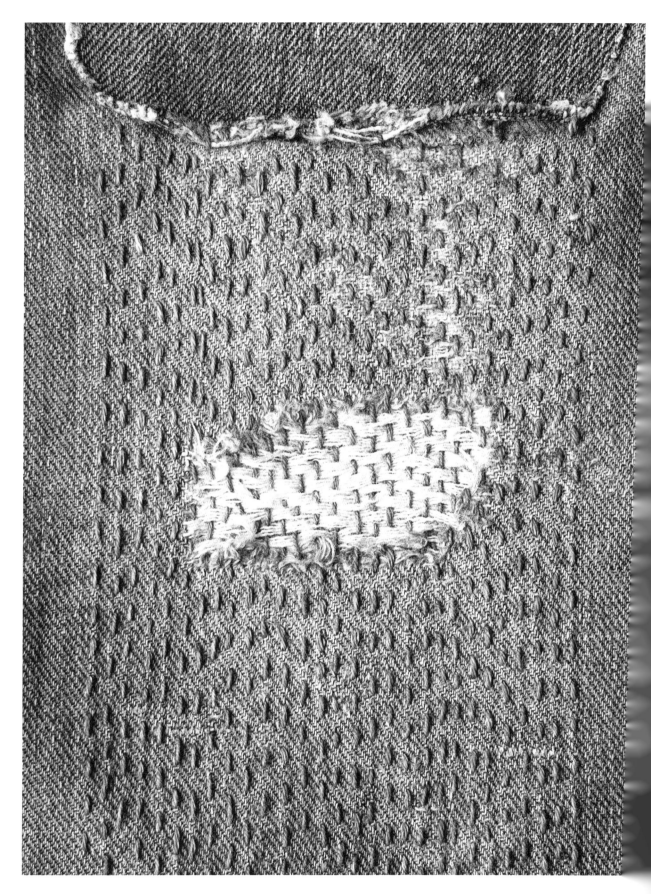

Jeans patched with indigo-dyed cotton thread.

PATCHING WITH RUNNING STITCH

Running stitch is the easiest sewing technique you can imagine: you just sew up and down through the fabric. You can mend using this technique with all kinds of thread and it's seen on garments across the whole world. In the photograph opposite, we have used an indigo-dyed cotton thread that is thicker than standard sewing thread to make the stitches more prominent. On the inside of the hole, we have used a little bit of textile glue to fasten a patch that has then been sewn properly into place with the running stitch. The finished mend is both decorative and strengthening.

— *patch*
— *textile glue or sewing pins*
— *needle*
— *thread*

The patch you are using for the mend should be large enough to cover the thin and worn material around the hole. If you only patch up the hole, there is a risk that the fabric next to the patch will rip when the garment is worn.

Start by securing the patch to the area behind the hole. You can use pins, tacking (basting) stitches or a little bit of textile glue to keep the patch in place while you work. Only use a small amount of glue, or you can end up with stains on the right side of the garment.

Sew back and forth with running stitches over the whole surface of the torn fabric to attach the patch. Both the stitches and the patch will help mend the garment and give it a longer life. To ensure a smooth and even result, don't pull the stitches too tight.

DARNING

This type of mending involves building up new weave that covers the hole. It's best suited for smaller damages in the fabric – up to about $1cm^2/\frac{1}{2}in^2$ – or for strengthening the fabric where it has become weak. If you are careful with thread, colour and stitching, you can create a mend that is close to invisible, but there is also the option to work with contrasts and let the mend show.

— *needle*

— *thread*

Imagine that you are working in the same way as a loom; to be able to weave you will first need to create the warp. In this case, the warp is made up of longer stitches that vertically cover the hole that is to be mended. Stitch threads over the hole that you want to cover and make sure that any weakened fabric around the hole is covered too.

You can then start to weave by going over and under every other warp thread with the needle and thread. Make sure to alternate which threads you go over and which you go under when you begin again from the other side, in order to create a tight and durable darn. Press down the threads with the needle as you work to tighten the weave, and fill up any holes using the same principle as a loom. Continue until you think the result is tight and neat.

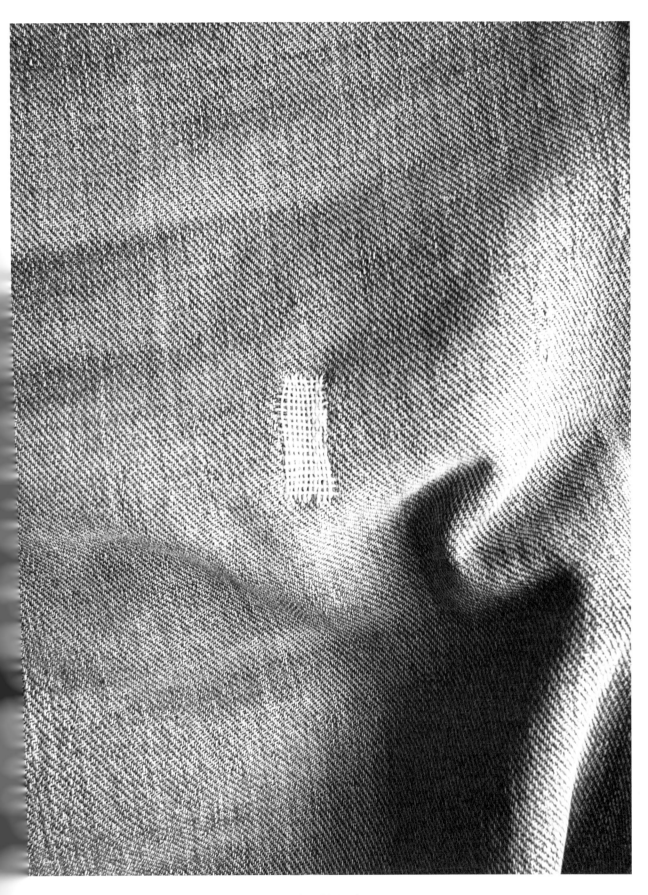

Jeans mended with darning.

PATCHING A HOLE WITH FOLDED EDGES

This patching is easy to do and will look striking. Here you start by folding in the edges around the hole. You can use pins or tacking (basting) stitches, but we prefer textile glue since it's easy to work with, plus it adds strength to the mend. But be careful when glueing – if you use too much glue you will get stains on the right side of the fabric.

— *scissors*

— *textile glue*

— *patch*

— *needle*

— *thread*

Start by cutting off the damaged fabric around the hole. It's important also to remove fabric that's worn out, since otherwise there's a risk that a new hole will appear next to the patch.

Turn the garment inside out so that you're working from the wrong side. Glue around the hole and fold about 3–4mm/⅛in of the edge in. Then glue around the hole again and place the patch carefully over the hole to avoid unnecessary visible glue stains.

When the glue is dry, you can sew around the edge to keep the patch in place. This way the stitches will become both decorative and strengthening.

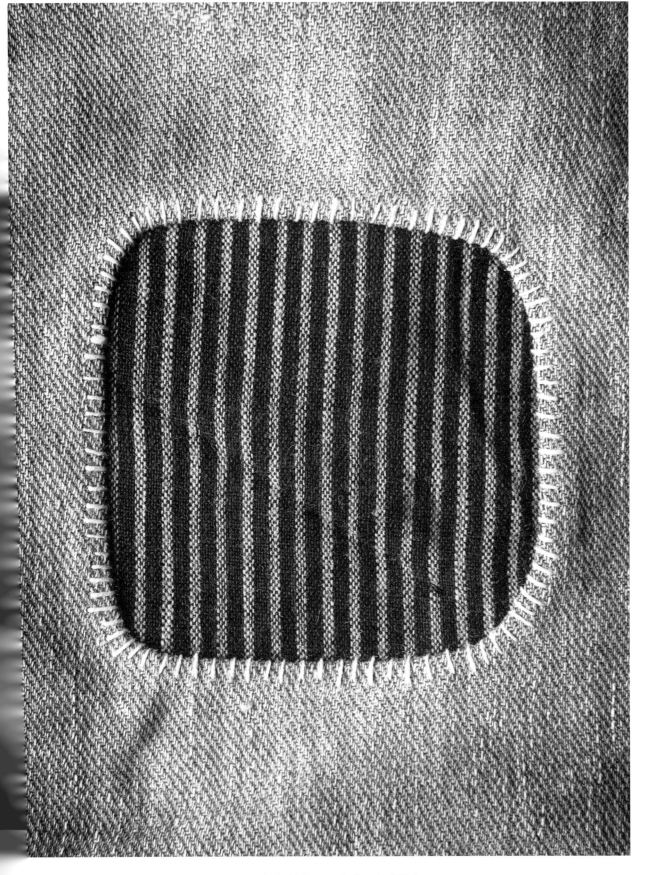

Jeans patched with Japanese indigo-dyed fabric.

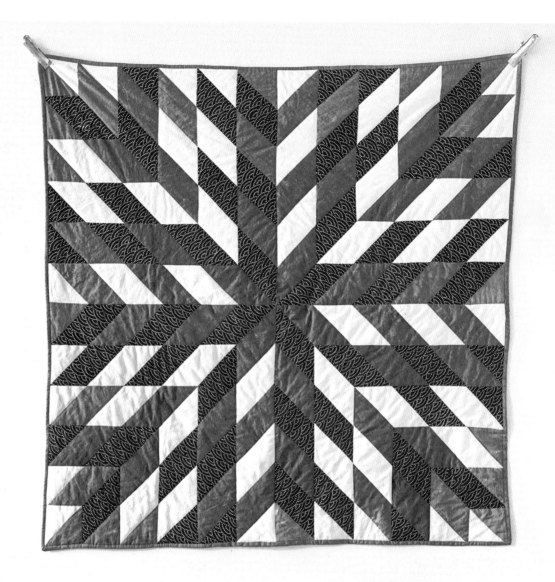

Front of the patchwork quilt.

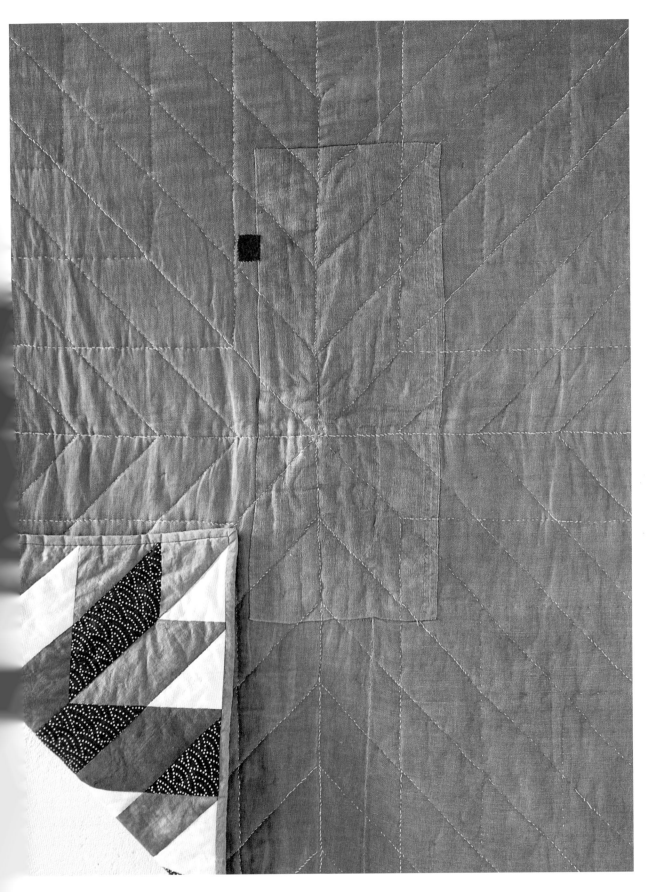

Reverse side of the patchwork quilt.

PATCHWORK QUILT

One thing we noticed when we started to dye with indigo was that our pile of test patches grew after every time we dyed. Finally we decided to make use of them by sewing a patchwork quilt. It felt good to do something useful with all the little by-products that the dyeing experiments left behind.

A patchwork quilt is a blanket that is made up of two layers of fabric that are sewn together with a layer of wadding (batting) in between. Today duvets are usually used as our bedding, but the patchwork quilt used to fulfil this function. Nowadays, the patchwork quilt is usually used as a throw.

Patchwork quilts have been important in many different cultures. Sewing blankets out of patches has always been a good way of using scraps or fabric from worn-out garments in order to create something functional and avoid waste.

The design of a patchwork quilt can be simple or complicated. Often, when you think of a quilt, what comes to mind is a geometric pattern that has been created by tessellating smaller patches. But there are also quilts that are made up of two whole pieces of fabric with wadding inside; they are called whole-cloth quilts and are distinguished by the pattern of prominent stitches that hold the layers together.

When sewing a patchwork quilt, you will need three layers: the top layer, a wadding layer and a backing layer at the bottom. You can use either cotton fabric or wool fabric, but it's good not to mix materials since that can make the quilt difficult to wash. The central layer can be made out of wool, cotton or polyester fibres, or you can just use a thin duvet or a woollen blanket. We use organic cotton wadding as we think it gives a nice weight and warmth.

Once you've got your three layers prepared, you can get to the actual quilting stage, a technique where you use needle and thread to sew through all the layers of the quilt. The purpose of the stitches is to keep all the layers in place. If your design uses

a lot of large shapes, then you will need to make sure that the pattern of securing stitches has a maximum gap of 10cm/4in between each row, or there is a risk that the central layer will start to move out of place. You can quilt using a sewing machine if the layers are not too thick, otherwise it will be difficult to reach the middle of the quilt. We recommend quilting by hand; it will take longer but will give a more handcrafted result.

For hand quilting, running stitch is often used, but other types of stitches such as blanket (prick) stitch and back stitch also work well. The quilting can be done in the seams in between the different pieces of the patchwork, or it can be stitched over the pieces and create its own patterns. Use a thread that is thicker than the standard sewing thread if you quilt by hand, or perhaps use a weaving or embroidery thread.

Patchwork quilts that are sewn this way can be washed, if this is done carefully. Hand wash in the bath or on the delicate cycle in the washing machine.

- *fabric for top and backing layers*
- *thick card*
- *scissors*
- *tailor's chalk*
- *thread*
- *sewing machine*
- *iron*
- *cotton wadding (batting)*
- *about 50 safety pins*
- *needle*
- *fabric for border*

Start by designing the front of the quilt. Decide how you would like the patchwork quilt to look and plan the pattern so that you can sew all the pieces together with straight seams. It could mean that you build up the pattern from squares or wedges that are sewn together into larger blocks, or that you sew strips of smaller pieces that are then all sewn together. Once planned, draw the pieces onto thick card and remember to include a 1cm/½in seam allowance. Calculate beforehand how many pieces you will need in order to save both time and material. Once that's done you can start cutting out pieces with the help of the stencil and tailor's chalk.

Organize the pieces in the order that they are to be sewn together. Sew using a straight stitch on a sewing machine with a 1cm/½in seam allowance. You don't need to zigzag since all the edges will end up inside the quilt, but it's important to press open the seams before you start sewing the larger blocks together.

When your design is finished, layer the backing fabric, wadding (batting) and top patchwork layer together. It's a good idea to make the wadding and the backing a little larger than the front. You can cut off the surplus later, but it would be a shame if the backing or wadding ended up smaller than the top layer. Make sure that all layers are flat and then secure them together with safety pins. Start in the middle of the quilt and continue out in a swirl, attaching the safety pins through all layers with approximately 30cm/12in gaps. Keep an eye on the layers to make sure they are not folded or stretched. When the whole patchwork quilt is secured with safety pins, you can then be sure that the layers won't shift while you work on it.

Start quilting! If you are stitching by hand you can place the patchwork quilt flat onto a table, with something protective underneath, such as a chopping board or a magazine. Starting from the top of the quilt, sew through all the layers.

126

Examples of patterns
that can be used to create
a patchwork quilt.

You can also quilt using the sewing machine if the layers aren't too thick, but it's a good idea to use a machine that has a walking foot, so that it evenly pushes all the layers along as stitches are made. Remember to take out the pins as you sew. Make sure you have a lot of space around the sewing machine so that the quilt can rest on the table to minimize the risk of pulling. When you're done, you can lay the quilt flat on the floor and trim the edges straight.

The last step is to add a border to your patchwork quilt. The border can be made out of fabric scraps that are sewn together into a long strip that is long enough to stretch around the whole quilt. The width of the fabric depends on what size border you'd prefer. If you'd like a border that's 2cm/¾in wide, for example, cut the strip so that it's 8cm/3¼in wide and sew it with a 2cm/¾in seam allowance. When you've sewn the strip onto the top side of the quilt, mitre the corners. Turn it over the edge of the quilt and sew it onto the backing by hand, so that the stitches can't be seen on the top side of the quilt.

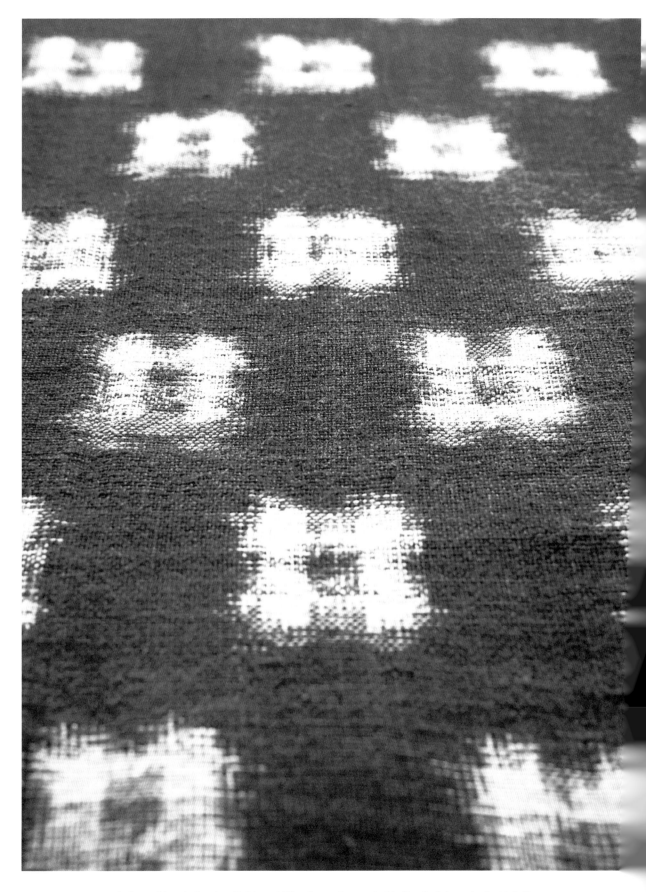

In Japan this technique is called *kasuri*. The picture shows a double *ikat* that's been dyed with indigo.

Ikat

Ikat is a resist-dyeing technique that is used to create patterns in a woven textile. It differs from other dyeing techniques, such as *shibori* and *batik*, where you create patterns by creating a resist on a fabric before dyeing. With *ikat*, the resist is done on the threads, before the fabric is woven. This is done by bunching up lengths of yarn that will later become the warp or weft. You then tie the threads in different places with a tight wrapping to create a pattern. The threads are dyed, and the wrappers are removed, exposing the undyed sections. The threads are then woven into a fabric, and it's only in the weaving process that the final result will appear.

The technique can be used to create more or less complicated patterns, from simple dots to detailed patterns of animals and plants. When you talk about *ikat*, there are three different categories: warp *ikat*, weft *ikat* and double *ikat*. Warp *ikat* is the easiest version with ties only on the warp. The same goes for weft *ikat*, but instead the ties are applied only onto the weft. In a double *ikat*, both the warp and the weft are tied; it is an art form in itself to get the undyed areas to meet at the right places in the weave.

Ikat textiles are most often characterized by a slightly blurred pattern, which is a result of the difficulty in aligning the threads accurately. For many people, that is precisely what makes *ikat* weaves so interesting to look at, and it's easy to become fascinated by the lively appearance of an *ikat* weave. *Ikat* is believed to be one of the oldest techniques for creating patterned textiles and different variations have been woven in several different parts of the world, including Africa, Europe Latin America and large parts of Asia.

Blue prints

It's easy to think that a blue print (not to be confused with an architectural blueprint) means a blue pattern that is printed onto a white base, but blue-printed fabrics have white patterns on a blue base. This resist-dyeing technique involves printing your chosen pattern onto the fabric with a thick paste that is then left to dry. During the dyeing process, the paste stops the dye from reaching the area underneath it. It can be made with either one of two substances: a sticky mixture that blocks the dye from being absorbed into the fabric, or a chemical that breaks down the indigo once it comes in contact with the fabric. After the dyeing, the paste is removed and the white pattern appears.

Wax, resin and combinations of the two can also be used for resist dyeing. We recommend using beeswax for simpler patterns. To remove the wax from the fabric, you can boil it in water with a generous dash of washing-up liquid. Use a saucepan that isn't too valuable as the wax has a tendency to stick!

In Swedish, the phrase 'blue print' (*blåutryck*) stems from the German word *blaudruck* and refers to the type of blue fabrics with white patterns that were printed in Europe mainly during the 18th and 19th centuries. The technique was particularly widespread and well liked in Eastern Europe, where it's not unheard of that farmers' clothes were entirely made out of blue-printed fabrics.

Also in Sweden, blue-printing has been a part of the traditional costume and has been used in smaller garments such as aprons and decorative collars.

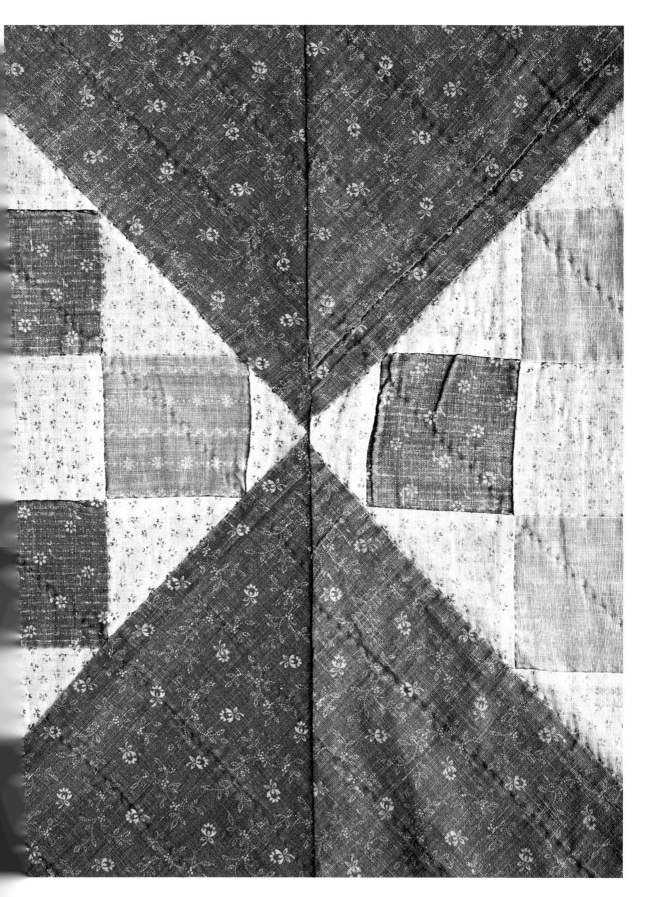

Indigo-dyed blue prints – detail from an antique patchwork quilt.

Materials

Natural fibres are divided into two categories: plant fibres and animal fibres. All materials that contain natural fibres can be dyed with indigo, but their capacity to absorb it varies. Silk and wool are animal fibres with a high protein content and therefore have a high absorption capacity, whereas linen, cotton and other plant fibres mainly contain cellulose, which absorbs less. Synthetic fibres are less suitable for dyeing, since the indigo won't fix as easily on them.

PLANT FIBRES

LINEN is made from flax (*Linum usitatissimum*), which is regarded as one of the oldest cultivated plants and has been used for centuries for producing yarn, thread and rope, among other things. Flax is a blue-flowering grass with a slender stalk, and it's the stalk that the actual fibres come from. In order to create a linen thread, the plant must first go through four different processes: retting, breaking, scutching and heckling.

Linen fabric absorbs moisture well and that is why it is frequently used for towels. The fibre is easy to recognize since it has a natural sheen and tends to crease easily.

COTTON belongs to the genus *Gossypium* which comprises of approximately 50 species, including both shrubs and trees. *Gossypium hirsutum* is the name of the species that is mainly grown for textile production. Larger plantations are best suited to a subtropical climate. Countries like Egypt, USA and Russia have been significant producers of cotton.

When the cotton flowers wither, a seed capsule develops that is wrapped in cotton fibres, and it's these fibres that are

refined and spun into cotton thread. Growing cotton plays a significant role in the economies of many countries but its history is linked with hard work and suffering, not least that associated with the slave trade. Today, there arc environmental problems in cotton production: large amounts of pesticides are often used and many of the plantations are located in very dry places where irrigation is necessary.

Cotton is durable and cool to wear in hot climates since the cellulose fibre reflects heat. The fibre soils easily, but since it's durable it can take being washed at high temperatures. These qualities – along with a low price point – have made cotton arguably the most popular fibre when it comes to textile production.

Boll weevil

During the late 19th century, the boll weevil – an insect pest – migrated from Mexico to the USA and fed on the cotton plant's buds and flowers. This quickly became a disaster for a large part of the country's cotton industry; the areas hardest hit were in the southern states where most of the cotton was cultivated. This was soon followed by the economic hardship of the Great Depression in the 1930s, resulting in devastating effects for these areas. The boll weevil later became a large problem in South America.

Today, measures have successfully been put in place to control the hungry beetle, but it will always remind us that our society can be very vulnerable when you consider that a tiny insect can ruin a whole industry and jeopardize the economy of an entire country.

SILK There are several different species of silk larvae; the one most often used in silk production is called *Bombyx mori* or the mulberry silkworm, so–called because it feeds on mulberry leaves. When the larva is ready to pupate, it spins itself into a cocoon that is made up of one single long thread. Most silk larvae that are bred for the silk industry never reach the butterfly stage, since it would mean that the butterfly would cut the silk thread to exit the cocoon. The silk cocoons are instead heated in hot water, which kills the larvae. The thread, which can be up to about 300 metres/330 yards long, can be then unwound. However, you can also get wild silk, or ethical silk, which is spun from the cocoons that butterflies have emerged from, so is made up of shorter fibres.

Silk is light and feels cool when you are warm and warm when you feel cold. It is strong if it is pulled in the direction of the fibres, but loses up to 20 per cent of its strength when wet and is not considered durable. The art of silk weaving first appeared in China, where a piece of silk dated to 3,600 BC has been found.

WOOL is made from the coat of several different animals, but mainly sheep. The method of using wool fibres as a base for textiles is probably one of the oldest, and today sheep's wool is a particularly important fibre. The majority of all wool that is used today for clothes production comes from merino sheep which have been bred to have a soft, finely waved wool with long fibres. The sheep are shorn once or twice a year and the wool is then washed, carded and spun into thread.

Both wool and silk are relatively easy to dye with indigo, but since they are mainly made up of protein, they can start to break down in alkaline conditions that become corrosive. It's therefore recommended to keep the pH balance between 7 and 8 when dyeing animal fibres.

From the top down: silk, cotton, wool and flax, from raw material to fabric.

Glossary

A collection of words and concepts that are included in the book. If you come across something that you don't understand, we hope that you will find the answer here.

ALKALI An alkaline substance with pH value above 7.

ALUM Potassium aluminium sulphate, which is extracted from alum slate or bauxite. It is used for fixing a dye to a textile in a process that's called mordanting.

BASTING STITCH See tacking stitch.

BATTING See wadding.

BLANK BATH A dye vat where all the ingredients apart from the indigo have been added.

DENIM A twill woven fabric with an undyed weft and a warp that is dyed with indigo

HAPA-ZOME A technique that involves pressing plants between two pieces of fabric to create a print.

IKAT A dyeing technique for creating a pattern in a woven textile.

INDIGO A colour and blue pigment that can be extracted naturally from plants or be chemically produced.

INDIGOTIN Pure indigo molecules.

INDICAN Made up of indoxyl and glucose. Can be found in plants.

INDOXYL A preliminary stage of indigotin. It can be found in plants where, together with glucose, it makes indican.

MORDANTING A way to prepare the textile to increase its ability to soak up more dye.

OPEN-PRESSED SEAM Pressing two sewn pieces of fabric apart so that the seam allowance is pressed open.

OXIDATION A chemical reaction. In this book it refers to when a textile is taken out of a dye bath and comes in contact with oxygen, making the blue colour appear.

PASTING To prepare indigo pigment for dyeing by stirring it together with a small amount of liquid.

PH VALUE A measurement of acidity in a liquid.

REDUCING A process where the indigo is changed into a state where it can fix onto a textile fibre.

RESIST DYEING A technique to keep dye away from specific parts of a textile in order to create a pattern.

RUNNING STITCH A simple stitching technique where the stitches are sewn up and down through the fabric.

SASHIKO Japanese word for an embroidery technique that involves sewing patterns in running stitch.

SHIBORI An umbrella term for different Japanese resist-dyeing techniques.

SHARPENING THE BATH To add substances to a dye vat in order to make the indigo return to its dissolved state.

SOAPING Heating up a textile for a certain period of time to increase the colour fastness.

STOCK SOLUTION Before the indigo is added to the dye vat, you mix it together with a small quantity of water, an alkaline substance and an oxygen-reducing substance. You then wait until the reduction has taken place and then pour the stock solution into a blank bath.

TACKING STITCH A loose running stitch that is sewn to keep parts of a sewing project in place during the sewing process. When the sewing is finished, the tacking stitches are removed, meaning they fulfil pretty much the same function as a sewing pin.

TANNINS Bitter substances that occur in plants and that have a capacity to bind proteins. Used in plant dyeing as a mordant.

TWILL A basic type of textile weave. Denim, for example, is twill woven.

VAT A dye bath where the indigo, by oxygen reduction and high pH value, is changed into a state where it can fix onto a textile.

WADDING A layer of padding between the outer layers of a quilt to provide warmth.

WARP A horizontally strung system of threads that is used for weaving.

WATER BATH Also known as a bain-marie, this is when a small vessel is lowered into a large vessel that is filled with warm water in order to heat up its content.

139

WEFT The thread that runs in between the warp threads in a loom to create a fabric.

WOOD ASH LYE A liquid that is made by adding ash from leafy trees to water to extract alkaline substances. It can be seriously corrosive. Wood ash lye is traditionally used for cleaning and can also be used for increasing the pH value in other solutions, for example an indigo vat.

Acknowledgements

With thanks to:

Elisabeth Fock without your enthusiasm and hard work we would
never have got this far

Maria Nilsson for recognizing our work and giving us a chance
to write a book

Kaili Maide for fresh plants and great help with the growing projects

Fredrik Ottosson for the beautiful photographs

Sebastian Wadsted for the design

Therése Karlsson for the illustrations

Lina Nääs for your librarian input

Mia Olsson for tips and support

Rieko Takahashi for your helpfulness

And everyone else who has contributed with tips,
information and recipes

Photographs: Fredrik Ottosson

Graphic design: Sebastian Wadsted

Illustrations: Therése Karlsson

Editor: Elisabeth Fock

English translation: Frida Green